# Pierre-Auguste
# Renoir

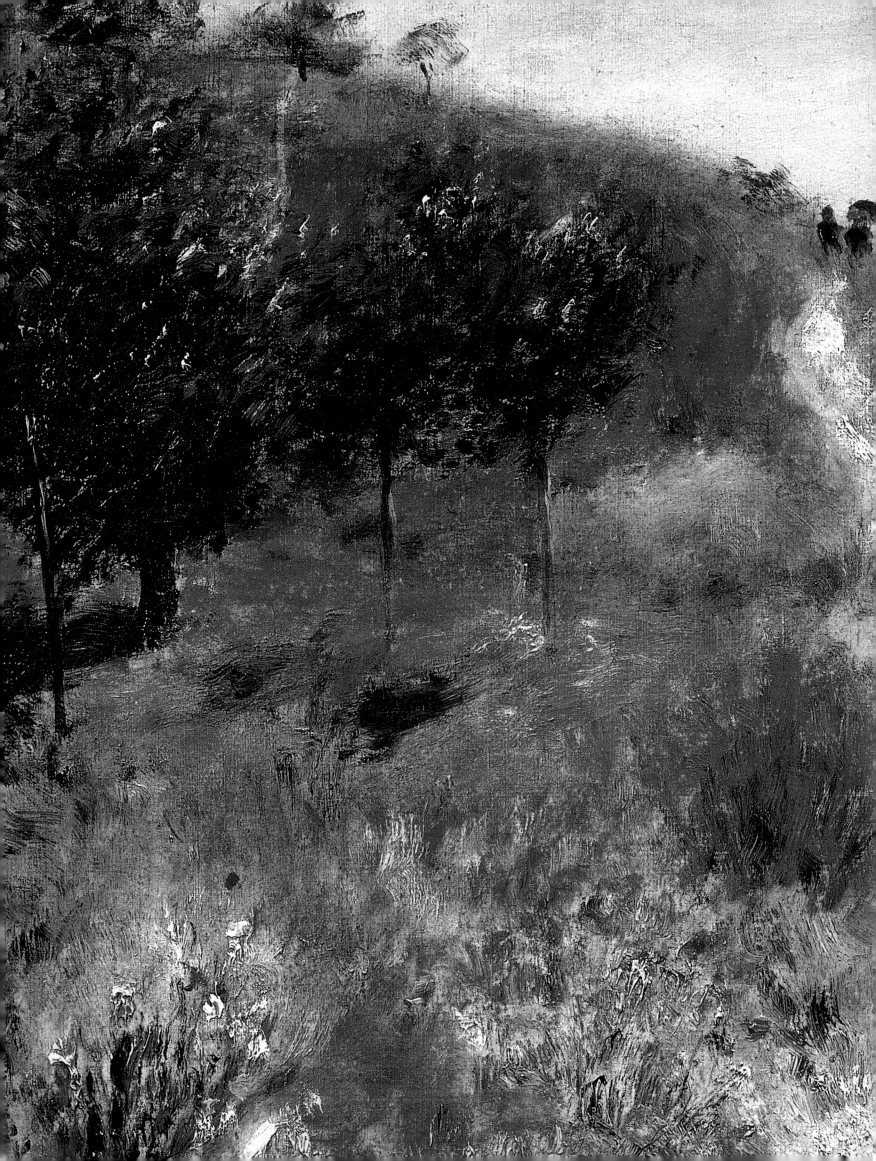

# Pierre-Auguste Renoir

Trewin Copplestone

Grange
BOOKS

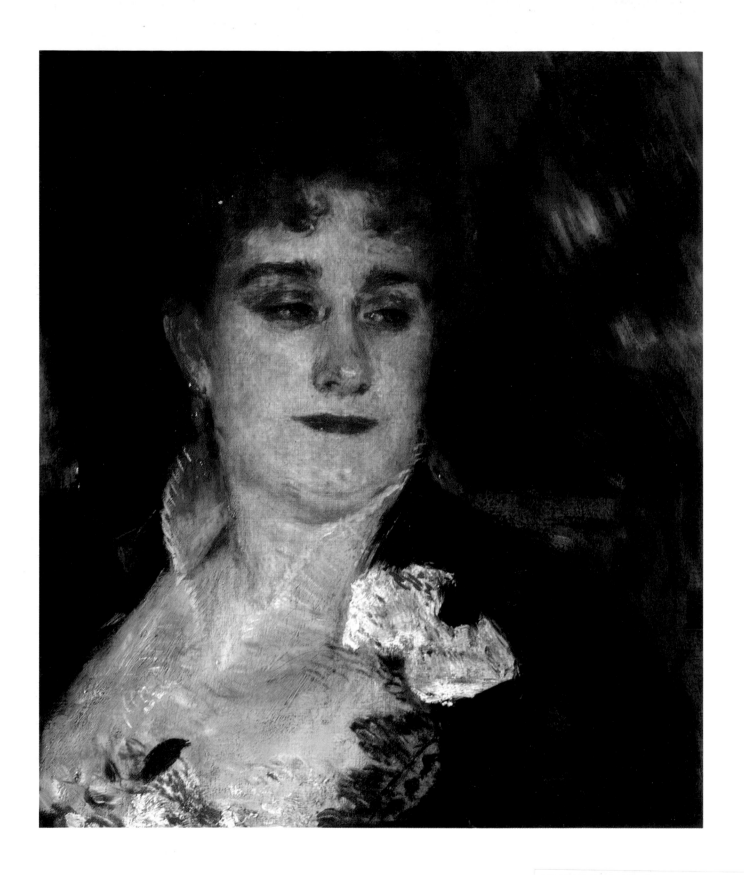

Published in 1998 by
**Grange Books**
An imprint of Grange Books Plc
The Grange, Units 1-6
Kingsnorth Industrial Estate
Hoo, Nr Rochester
Kent ME3 9ND

ISBN 1 84013 166 7

# List of Plates

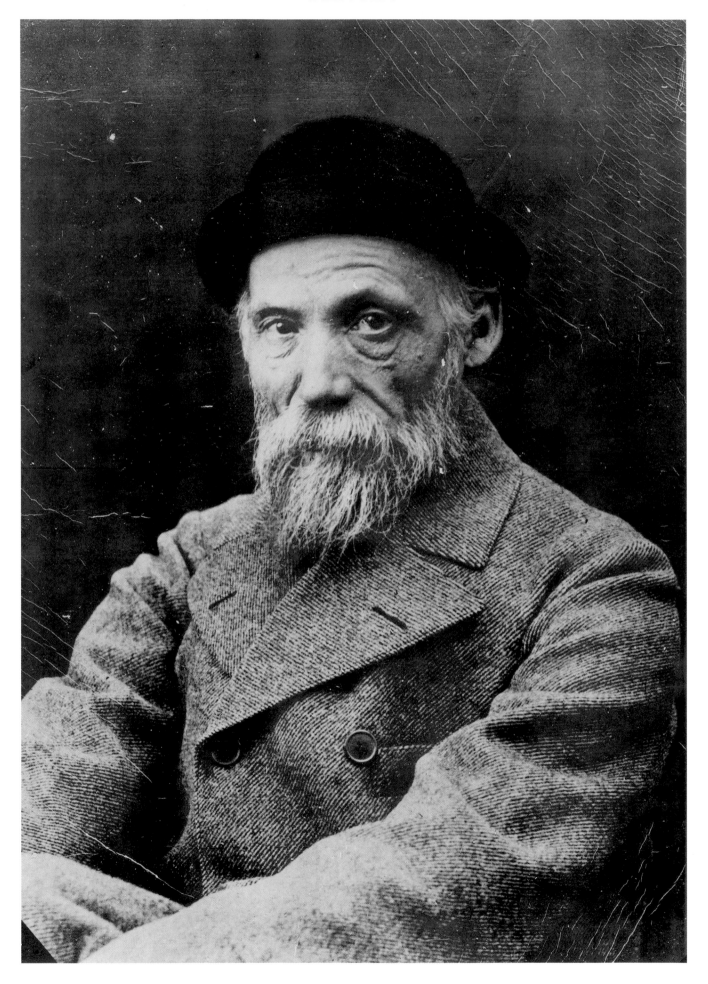

PLATE 1
## Photograph of Pierre-Auguste Renoir

The history of Impressionism includes a few painters who are central to its development and a large number who are peripheral but nonetheless important because they add some small piece to the large jigsaw that is the Impressionist revolution. There are perhaps four painters at the centre of the movement, each contributing something essential in its initial creative stages. The four are Monet, Pissarro, Sisley and Renoir, the role and contribution offered by Renoir being the least easy to define. His participation in the creation of what has become known as Impressionism is unquestionable and during the period that he was working closely with him, his work certainly has an affinity with Monet's. But outside this relatively short association of a little more than a decade, Renoir's work goes through a number of developments, both before and after, that appear to have but little connection with the characteristics that are familiarly Impressionist. However, the general character and philosophy of the movement will be recognized in his work. Perhaps what it is important to establish is the earlier development of Renoir's life before he encountered those painters in whose company the stylistic and philosophical character was developed, and also to examine the work that he produced after the break-up of the movement into independent directions after the last Impressionist exhibition in 1886.

One general point, however, is undoubtedly true;

Renoir has been for so long and so positively described as an Impressionist that, however difficult it may be to accommodate his work at some stages, he will always be known as an Impressionist. This may be unfair to his overall aims and achievement and limit recognition of his non-Impressionist work, even to devalue it. Further, his artistic aims, his attitude to painting as declared by him and revealed in his temperament are ultimately far from that of other Impressionists, Monet or Pissarro for instance, however superficially similar they may seem. Of course, this is not surprising; as we are constantly being reminded, we are all different with a unique experience and philosophy. Nor do we remain through life the same individual as when we began it. Renoir, at the age of 22 when in the studio of Gleyre, learning methods and technique as a student with Monet and Bazille, had been accused by Gleyre on one occasion of 'seeming to take painting as a pleasure', Renoir's reply: 'Quite true, if painting were not a pleasure to me I certainly should not do it.' This is perhaps a more significant remark than even Renoir knew since from the beginning of his working life he was in search not only of satisfaction in labour, a job well done, but pleasure, and even delight, in what he did.

His life did not start propitiously. Pierre-Auguste Renoir was born at Limoges, in central France, on 25 February 1841 the fourth of five children. Two painters, both part of the Impressionist revolution, and later to

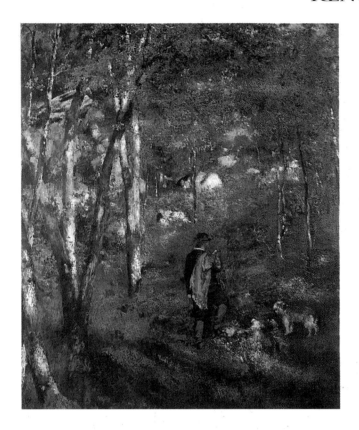

## PLATE 2
### The Painter Lacoeur in the Forest of Fontainebleau (1866)
Oil on canvas, 41³/₄ x 31¹/₂ inches (106 x 80cm)

*The influence of two of Renoir's early mentors can be seen in this painting. The general effect of the work shows the quality of Courbet in its heavy paint and sturdy drawing and in its plein-air treatment in the Forest of Fontainebleau, the impact of Diaz's admonition to him two years earlier to stop using black. Painted while he was staying at Marlotte, near Fontainebleau, the painting represents only one aspect of Renoir's style at that time since, while at Marlotte, he also painted* The Inn of Mother Anthony, *a scene at the inn at which he stayed, with his friends, Monet, Bazille and Sisley all depicted in it. This painting is dark and with much black and linear outlining.*

## PLATE 3
### Portrait of Frédéric Bazille (1867)
Oil on canvas, 41¹/₃ x 29 inches (105 x 73.5cm)

*Bazille, born in Montpellier, had originally been expected by his father to follow a medical career but the attraction of painting drew him to Paris and Gleyre's atelier where he met Monet, Sisley and Renoir and they were close friends until Bazille was killed in the Franco-Prussian War of 1870. Bazille was talented, and painted his friends in their studios as well as himself acting as a model for them. He was tall and thin, as is evident in the crouching pose in this painting, and he is consequently easily recognizable in their paintings. For example, he appears twice in Monet's* Déjeuner sur l'herbe. *Renoir's style at this time still owes much to Courbet and is not an 'Impressionist' work. It is constructed on the academic tonal method and is far closer to Manet than the paintings of his friends.*

become his friends, Frédéric Bazille and Berthe Morisot, were born in the same year. Renoir's father was a small-time tailor who despite making a meagre living appears to have been concerned for his sons' futures as well as wishing to improve his own circumstances, and moved with his family to Paris when Pierre was 4. Although he had little means, he nevertheless was interested in *objets d'art* in a way that many of the *petite bourgeoisie* were, and even hoped that his sons might have work of an artistic, if humble, kind. Renoir's mother, too, had a sensitive nature and was accustomed to taking her sons for walks in the woods, drawing their attention to the beauty and endless variety of nature.

Pierre-Auguste was a good-humoured and serious-minded youth with a conscientious spirit. At school in Paris he showed an early talent for drawing and had a good ear for music. He sang in the choir of the local church where the then unknown Gounod was choirmaster. One of his brothers had already shown an inclination towards the arts and was an heraldic engraver when, at the age of 13, Pierre-Auguste was apprenticed to a china manufacturer, a trade that was part of the proud traditional heritage of Limoges. His father hoped that he would have a profession for life as a painter on porcelain and might even become a painter in the great porcelain factory at Sèvres, then on the outskirts of Paris.

Renoir was later to recall that it was his job to

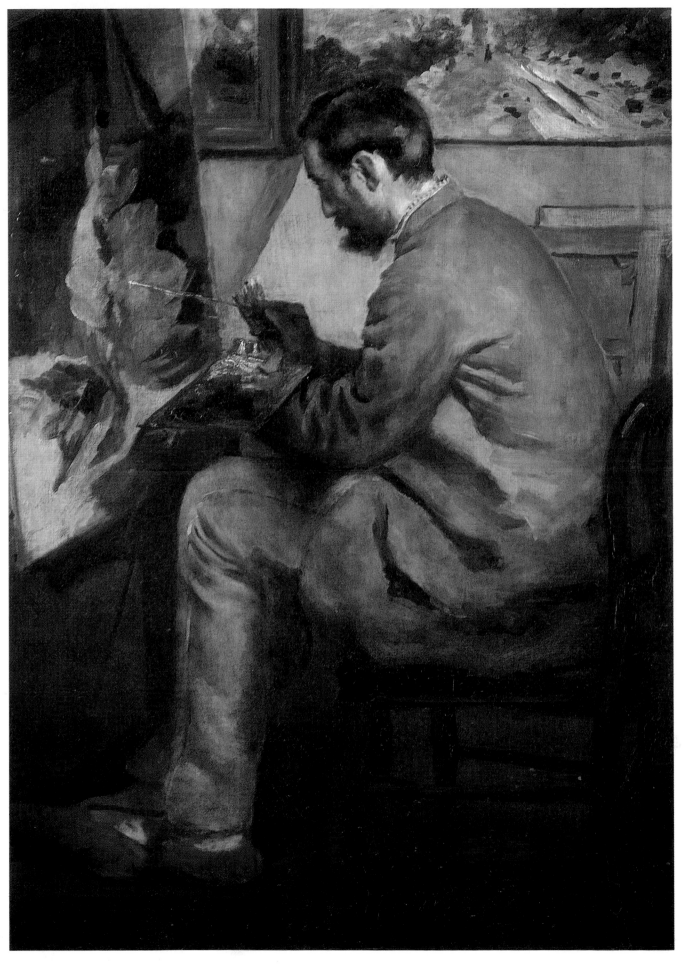

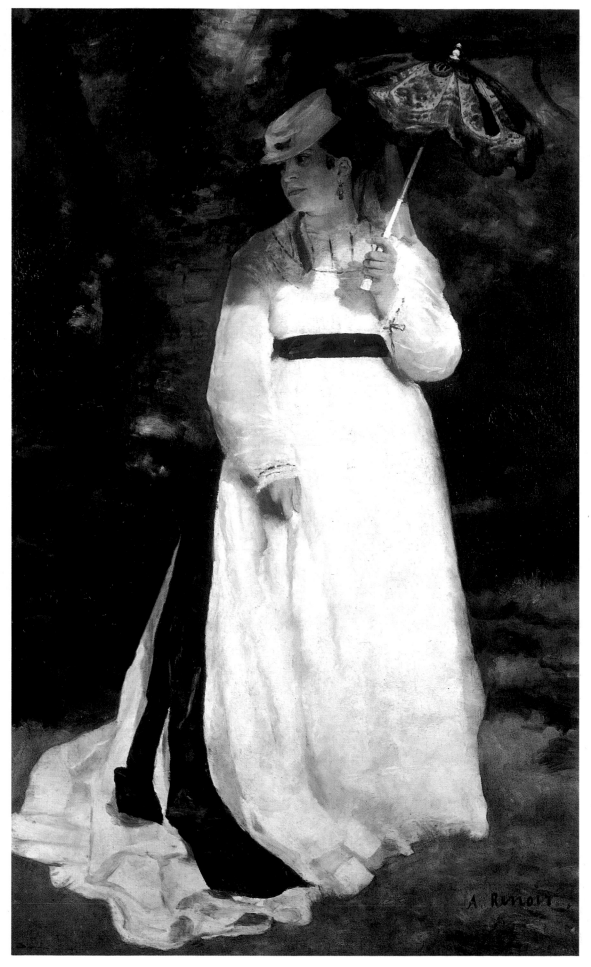

PLATE 4
## Lise with a Parasol (1867) opposite
Oil on canvas, 71²/₃ x 46¹/₂ inches (182 x 118cm)

*At this time, Renoir was hoping to make an income from portrait-painting and submitted to the Salon each year after his Esmeralda Dancing with her Goat was accepted in 1863, other works being rejected in 1864, accepted in 1865, and refused in 1865, 1866 and 1867. His* Lise with a Parasol *was accepted in 1868. Lise Tréhot was 16 when Renoir painted her, and he saw her as an ideal subject, physically mature but still retaining the freshness of youth. The portrait shows the influence of Manet in the dramatic opposition of dark navy-blue belt and sash and brilliant white dress, but with its closely modelled paint treatment and careful drawing of an atmospheric sun-dappled background not derived from Manet.*

PLATE 5
## Boy with a Cat (1868) below
Oil on canvas, 48¹/₂ x 26 inches (123 x 66cm)

*This strange and unusual study was undertaken when Renoir was concerned with the academic qualities of draughtsmanship and he made a number of nude studies which usually acquired a classical title. A painting of a nude Lise from the previous year was turned into a 'Diana' by the addition of a dead deer and an archer's bow. In this painting no such alternative seems obvious and the careful drawing of the figure and the fat contented cat remain an example of Renoir's pursuit at this time of fine painting within the academic tradition.*

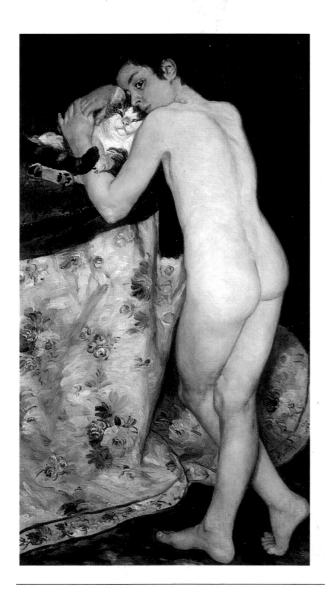

'sprinkle tiny bouquets on a white ground, for which I was paid five sous a dozen', adding that the unscrupulous manufacturer stamped everything with the Sèvres trademark. Renoir progressed in his work to such an extent that he eventually received eight sous for profiles of Marie Antoinette! Unfortunately, as it seemed at the time, the factory was forced to close in 1858 when the development of machine decoration made hand-painted porcelain too expensive to produce. However, Renoir had learned much that was to be of value to him later. He had learned to paint delicately with thin pointed brushes and to use paint to create a striking luminosity.

While at the factory he had also developed an interest in art and in his lunch break visited the Louvre, being especially fascinated by Goujon's *Fontaine des Innocents*, 1547-49. His interest in sculptural form was aroused by this work and by the visits he made in the evenings to the studio of a sculptor who was also employed in his factory. He was particularly attracted by the full and rounded female forms of the models in his friend's studio and they became a recurrent feature of his later work.

When the factory closed Renoir had to look for work of a different kind. For a time he painted decorative fans – 'God knows how many times I copied the *Embarkation for Cythera*!' He claimed that the first painters he got to know were Watteau, Lancret and Boucher, the great rococo artists of the early 18th century in France. Boucher's *Bath*

PLATE 6
## Bather with her Griffon (1870)
Oil on canvas, 72½ x 45¼ inches (184 x 115cm)

*The subject of this painting is again Lise Tréhot but without the classical trappings. In this painting Renoir was influenced by the work of Courbet and the pose is reminiscent of him. The fact that the dog is a griffon, a creature with mythological*

*associations, may have some significance since he submitted it to the Salon of 1870 and it was accepted. While he was exploring pictorial possibilities with such paintings as those he produced while working with Monet at La Grenouillère, Renoir continued to paint more traditional subjects, particularly nude studies for exhibition at the Salon, remarking that if showing at the Salon did no good, it at least did no harm.*

*of Diana*, a voluptuously exotic nude, remained a favourite painting – perhaps reinforcing his interest in the female form. The fan-painting provided him with only a pittance and he abandoned it when offered the somewhat curious opportunity of painting blinds for missionaries. These were intended to take the place of stained-glass windows in their far-flung improvised places of worship. Thus, from the exotic subjects of the fans he turned to religious subjects, the most popular apparently being the 'Adoration of the Magi' and 'St. Vincent de Paul'. He produced these with such speed and facility that he was soon making and saving money. His personal ambition, the drudgery of the repetitious work and the fact the he had some money, encouraged him to pursue a life of art. He had survived life as an artisan with limited horizons with his cheerful spirit intact and he looked forward to learning the higher levels of painting with keen anticipation.

In 1862, at the age of 21, Renoir took courses at the École des Beaux Arts and at the same time entered the studio of Gabriel-Charles Gleyre, mentioned earlier, a Swiss painter who had come to Paris and taken over the former studio of a successful academic painter, Paul Delaroche. He, too, was a successful teacher and his atelier was one of the most popular in Paris. Once there, he met as fellow students Monet, Sisley and Bazille. Whistler had also been a student with Gleyre but had left before Renoir arrived. Renoir was not impressed or inspired by Gleyre's teaching and with

others left the following year, galvanized by a visit to a show by Manet at Martinet's gallery and, finally, by the Salon des Refusés, a seminal occasion for the development of Impressionism.

The importance for these young students of the Salon des Refusés cannot be over-emphasized. Édouard Manet, a painter only a little older than Renoir, in 1863 submitted to the annual Salon held in the Grand Salon of the Louvre (hence the name) to which all the great academicians sent their latest work and in which Renoir actually had a painting accepted, *Esmeralda Dancing with her Goat*. The Salon was the most important Parisian artistic gathering of the year and was that year opened by the emperor Napoleon III. In the course of general conversation, Napoleon suggested that the rejected paintings should be shown in other vacant rooms in the palace, thus emphasizing by comparison the superiority of the main Salon, and suggested that the exhibition be called the Salon des Refusés. Naturally, he was taken seriously. Manet's painting was one of those not accepted for the Salon and thus found its way into the Salon des Refusés. Called *Le déjeuner sur l'herbe*, it caused such a serious scandal that the Refusés experiment was not repeated. This, however, had the effect of making the notorious Manet even more attractive to the young independently minded young painters at the time, including the four at Gleyre's.

Manet's painting was of an unusual picnic scene

*Continued on page 21*

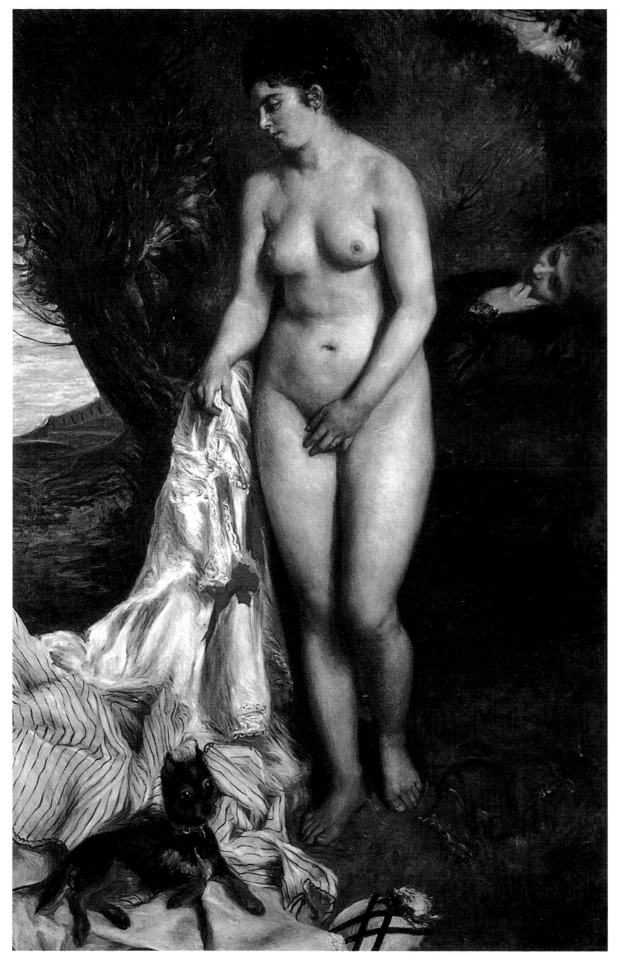

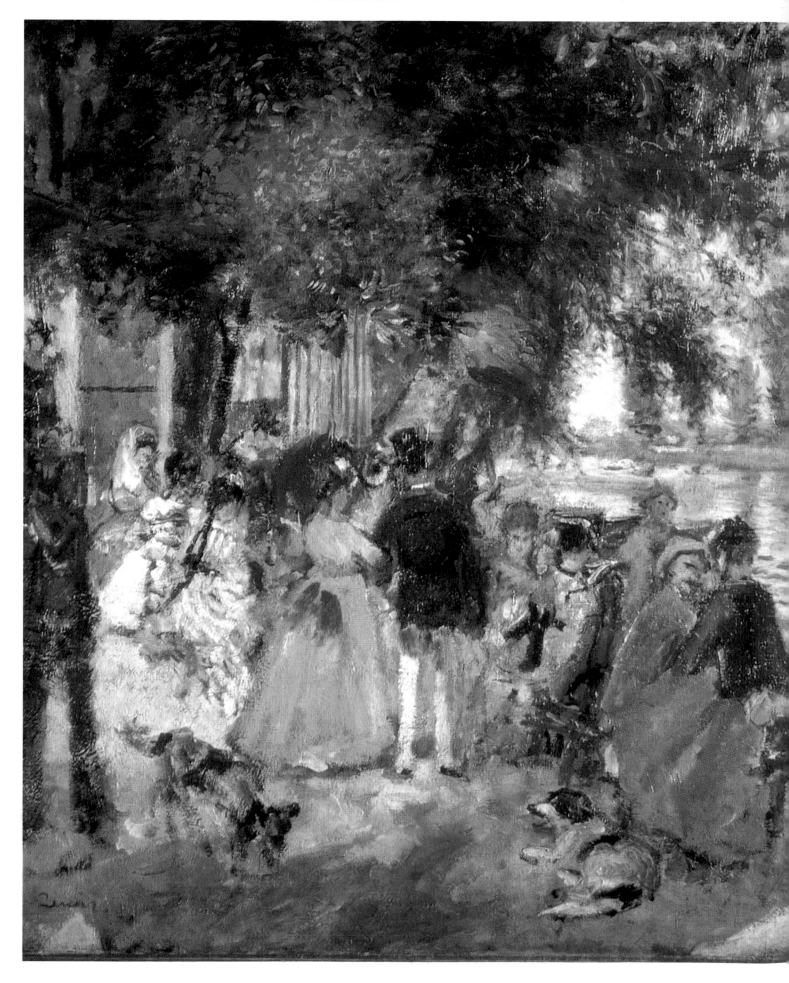

PLATE 7
## La Grenouillère (c. 1869)
Oil on canvas, 23¼ x 31½ inches (59 x 80cm)

*Although painted round about the same time as the previous work, Renoir here reveals an evident progress towards Impressionism. And this is perhaps not surprising when it is recalled that he painted with Monet at this time and La Grenouillère was a favourite recreation spot for Parisians. La Grenouillère was on Croissy Island in the Seine near Bougival and was, in a contemporary report, '...inhabited by a swarm of writers, men and women belonging to the artistic life of Paris ... along the banks at certain hours of the day, sometimes fishing, sometimes for the pleasure of bathing in open water.' It became a social fad when Louis Napoléon and Eugénie condescended to visit the place in 1869. Monet and Renoir, neither of them permanently located, naturally gravitated here and painted side-by-side, each to some degree influencing the other. It was a preparatory stage in the evolution that took definite form at Argenteuil in the early 1870s.*

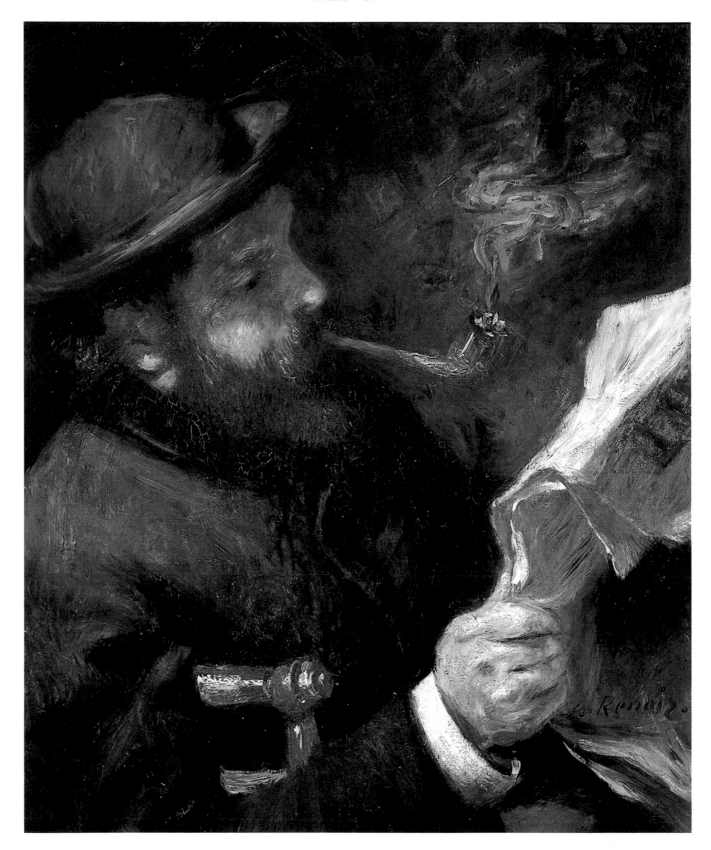

PLATE 8
**Portrait of Claude Monet** (1872)
Oil on canvas, 24 x 19²/₃ inches (61 x 50cm)

*At this time, Renoir had a studio in Paris and stayed and painted with Monet at Argenteuil. They had a close and friendly working* relationship and Renoir participated in the first Impressionist exhibition arranged by Monet and Degas. This is not a characteristic Impressionist work although the short brushstrokes owe something to Monet, the density of the dark near-black over large areas of the canvas giving solidity to form rather than light.

PLATE 9
# Portrait of Claude Monet (1875)
Oil on canvas, 33½ x 23¾ inches (85 x 60.5cm)

*Comparison with the portrait painted three years earlier (plate 8) reveals how far Renoir had travelled towards an Impressionist technique of small touches – sometimes described as 'comma' strokes – with undefined outlines and a pervading sense of light. The painting was exhibited in the second Impressionist exhibition and was well received by the critics. Renoir made a number of portraits of Monet around this time, including one of Monet painting in his garden at Argenteuil. Although this and the previous painting may be taken to be part of Impressionism, Renoir was always searching for new means of expression and his style during the period of the 1870s varies so much that Renoir's Impressionism, unlike Monet's, has no clear indisputable identity.*

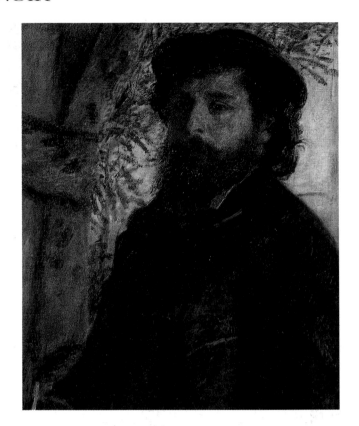

Continued from page 16

containing two elegantly dressed young men-about-town reclining on the grass accompanied by a naked female who is looking directly out of the picture at the viewer, bold-eyed and challenging. The fourth figure in the background is a scantily-clad female in the act of either robing or disrobing. It will be appreciated that nudes were familiar subjects for paintings, but were usually of such personages as Venus, Aphrodite, Hercules or Mercury which introduced an aura of unreality, antiquity and a link with the past history of art, being idealized and remote rather than merely plain naked. Not a wisp of body hair was visible and most such compositions were, in addition, given titles with classical and mythological associations such as the 'Garden of the Hesperides', and portrayed figures engaged in obscure pageants. As it happens, Manet had intended to modernize, to actualize in the present a composition taken from a painting by Raphael and probably seen by Manet in the form of an engraving by Marcantonio Raimondi. Manet, with this single painting, had fatally wounded the intellectual pretensions of the Académie and had demonstrated the possibilities of everyday life as a subject for the modern painter.

It took just over a decade for the impact of this painting, together with another of Manet's exhibited in 1865 and this time accepted by the Salon, called *Olympia*, another nude but reclining on a bed and again confronting

the viewer with the kind of bold invitation of women displaying themselves in lighted windows in Amsterdam. Another *succès de scandale*, it reinforced Manet's somewhat reluctant role as leader of the avant garde of young painters who began to meet in Manet's favourite Café Guerbois in the avenue de Clichy in the Batignolles district of Paris. These included Monet, Degas, Bazille and Renoir who, despite the urgent discussion which was a feature of their meetings, hardly spoke. He was not a theorist.

After leaving Gleyre's atelier, Renoir shared a studio with Bazille where the group also met. Each had their own personal enthusiasms for particular artists from outside the dimensions of the academic world. For Renoir, it was Diaz de la Peña, a member of the so-called Barbizon school who painted in the open-air in and around the Forest of Fontainebleau and included Millet, Rousseau, Dubigny, Dupré, Troyon and Diaz, all of whom influenced one or more of the Impressionists with their devotion to the landscape in which they lived and worked. At the first meeting between Diaz and Renoir in the forest where he was working, Diaz's advice to Renoir was that he should stop using black, a suggestion he immediately accepted with the result that he destroyed the painting that he had exhibited in the Salon of 1863. It was a turning-point in his career and the subsequent influence of Courbet and Manet must be added to the influences which affected a sea-change in Renoir's painting.

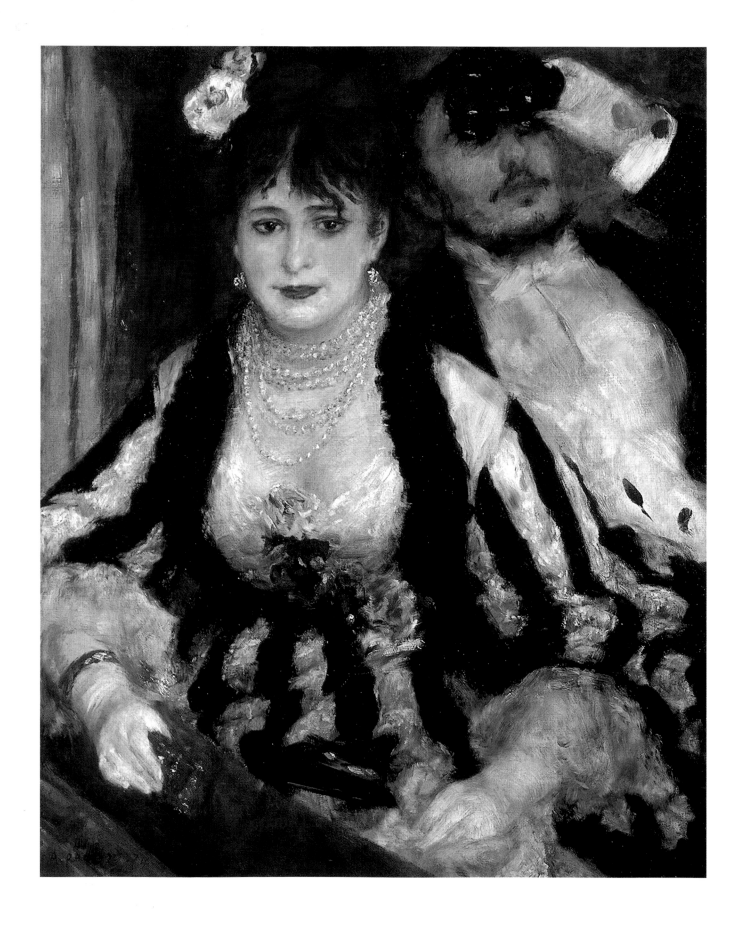

PLATE 10
## La Loge (Box at the Theatre) 1874
Oil on canvas, 31½ x 24¾ inches (80 x 63cm)

*For the affluent middle classes, Parisian life usually involved the regular attendance at theatrical entertainments where people went to see and be seen, which was possibly more important to them than the performance. This elegant and famous painting, one of Renoir's most delicate evocations of French society, reflects his delight in attractive women in privileged circumstances. Or so it seems: but in fact he chose a well known Montmartre model dressed in a startling broad-striped gown to portray a well-heeled society lady and his brother Edmond as the man-about-town in the background. Renoir's patrons for his main source of commissioned portraits would have been impressed by this pictorial tour de force, executed in thin paint and a strong tonal range. The significance of the location is also important and was a popular subject for illustration and portraiture. The theatre box would have been a natural location for the privileged, like Manet or Degas, but for Renoir, with his bourgeois background, it was an effort to enter into such a milieu which would provide him with the sitters he needed. The emphatic presentation of the figures in close-up (the man is hardly given sufficient depth in space to occupy) adds one more element of exciting immediacy, and the angle of the edge of the box on which the woman's hand rests is indicated in such a way as to suggest that the viewer is also in the next box – a participant in the event. Although this is a traditional treatment and Renoir uses black – a non-Impressionist colour but which Renoir described as the 'queen of colours' – he exhibited this work in the first Impressionist exhibition and it has become one of the most admired masterpieces of the Impressionist movement.*

In the years approaching 1870 and the outbreak of the Franco-Prussian War, Renoir continued to submit work to the Salon which was sometimes accepted, sometimes not. He experimented in an almost carefree manner with various techniques, on occasion using the heavy impasto of Courbet, sometimes the strong contrasts in brushstrokes of Manet. He was also beginning to associate closely with the proto-Impressionists. In 1869, for instance, he went to Louveciennes to see Pissarro as well as his own parents who also lived there.

The Franco-Russian War had a dramatic effect on the lives of the painters. Degas and Manet served in the French army, Monet and Pissarro avoided conscription by escaping to England, as did Sisley who was English although born in Paris. Bazille also joined the army but was unfortunately killed. Cézanne, disregarding call-up papers, went south to L'Estaque. Renoir, with his *laisser-faire* attitude, allowed matters to take their course, ended up in the army and was posted to Bordeaux, far from military action. When the war ended he remained in the area, painting happily for a time. His comment on his army career: 'I could nail down ammunition boxes like no one else – my captain found that I was possessed of the military spirit and wanted me to continue my life in the army.' In his characteristically light-hearted way he observed that had he taken up all the careers people had encouraged him to follow, what a life he would have had.

Once freed from the army and after two or three months, Renoir returned to Paris in search of portrait commissions and to paint the life of the city which was dear to his heart. He began to renew his friendships with his former associates. Particularly important at this time was the role taken by Monet who had replaced Manet as leader, much to that gentleman's relief. After the war, Monet had moved to Argenteuil, a small town on the outskirts of Paris on the banks of the Seine which became the focus of the group of young independent painters who had gathered around Manet at the Café Guerbois. The Argenteuil association resulted in the group's decision to hold an exhibition since they did not believe they were making enough headway towards the public recognition to which, by then, they considered they were entitled. As already noted, Renoir was not very interested in the various theories, the subjects of many discussions, and he continued to work with the influence of his early inspiration, particularly Courbet and Manet, and this mostly in the matter of technique rather than subject-matter. At this time, the group was not a close-knit organization but a number of independent artists who had similar career aims – to be successful and recognized. It was thus possible for Renoir to be part of the group without subscribing to any specific artistic philosophy.

Another to influence Renoir's technique rather than his subject-matter was Delacroix, whose method of

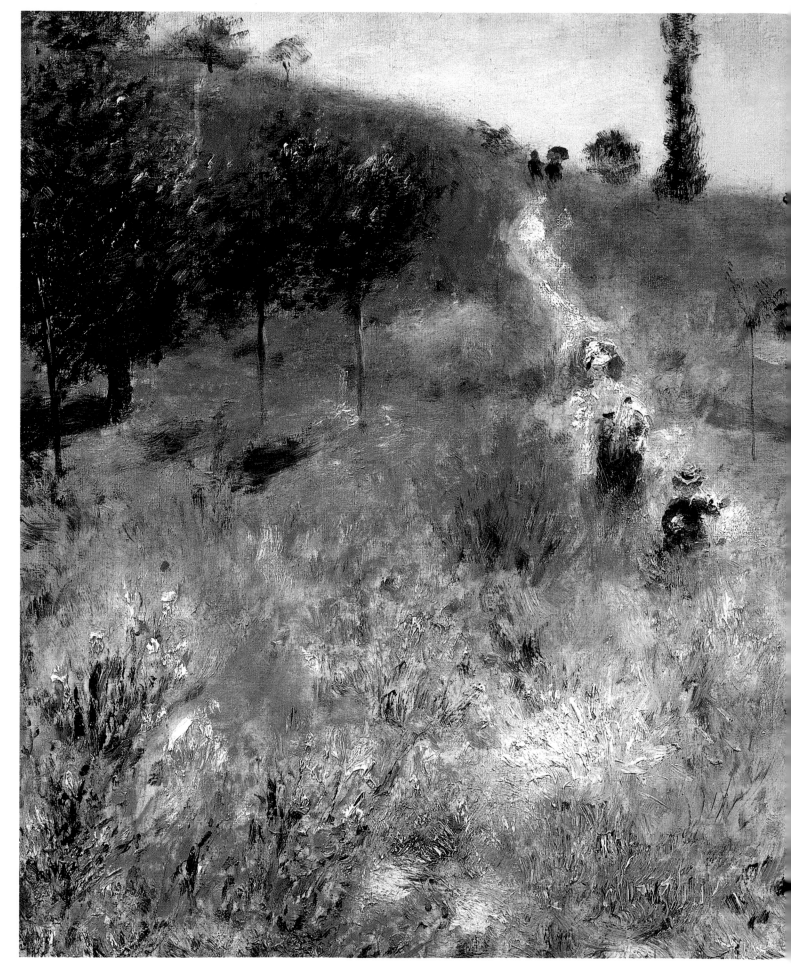

PLATE 11
## Path Winding Upwards through Tall Grass
(c. 1874)
Oil on canvas, 23²/₃ x 29 inches (60 x 74cm)

*Renoir varies his technique in response to the exigencies of his subject and his technical assurance by this time enables him to mix his methods to achieve precisely the effect he wishes. The grass in the foreground is painted in thick strokes, sometimes called his comma effect, to create the density he requires, while the background is laid in with thin, flat areas of colour which merge into one another to give the undefined identity of distance. The two figures give a central focus to the picture and are reminiscent of Monet's use of figures in his poppy-field paintings.*

applying paint, evidenced by Renoir's painting of 1872, *Parisian Women Dressed as Algerians* (plate 16), was directly inspired by Delacroix's *Women of Algiers*, a painting that has influenced a number of later artists who regarded it as inspirational subject-matter: for instance, Pablo Picasso in the 1950s. The strong painterly qualities of brush and colour which Delacroix produced, with a luscious exoticism, was a far cry from the dry tonal work of the academics, and was not only an important influence on all Impressionists but in Renoir's case returned him to the colour of the Venetians, Titian and Veronese, and to Rubens. For Renoir, Delacroix remained a hero and his *Women of Algiers* was one of Renoir's favourite paintings.

During the 1870s, Renoir was beginning to have some success, was submitting paintings to the Salon – frowned upon by the group, most of whom had abandoned the Salon. Renoir's response was typical: 'My submitting to the Salon is a purely business matter. Like certain medicines: if it doesn't do any good it doesn't do any harm.' During the period he painted some of his best known works including *La Loge*, 1874 (plate 10), *Le Moulin de la Galette,* 1876 (plate 15), *The Swing*, 1876 (plate 17), and *Madame Charpentier and her Children*, 1878 (plate 20).

The result of the discussions, and the fact that members of the group were painting together at Argenteuil, was that the first group exhibition was held in

PLATE 12
**Woman Reading** (1874–76)
Oil on canvas, 18¹/₃ x 15¹/₈ inches (46.5 x 38.5cm)

*Painted around the time of the first Impressionist exhibition, this study is more an examination of a lighting effect than a portrait. Renoir was always alert to different possibilities of subject and technique in combination, and his model with top illumination and reflection from the pages of her book must have posed an attractive problem which he tackled with an Impressionist brush.*

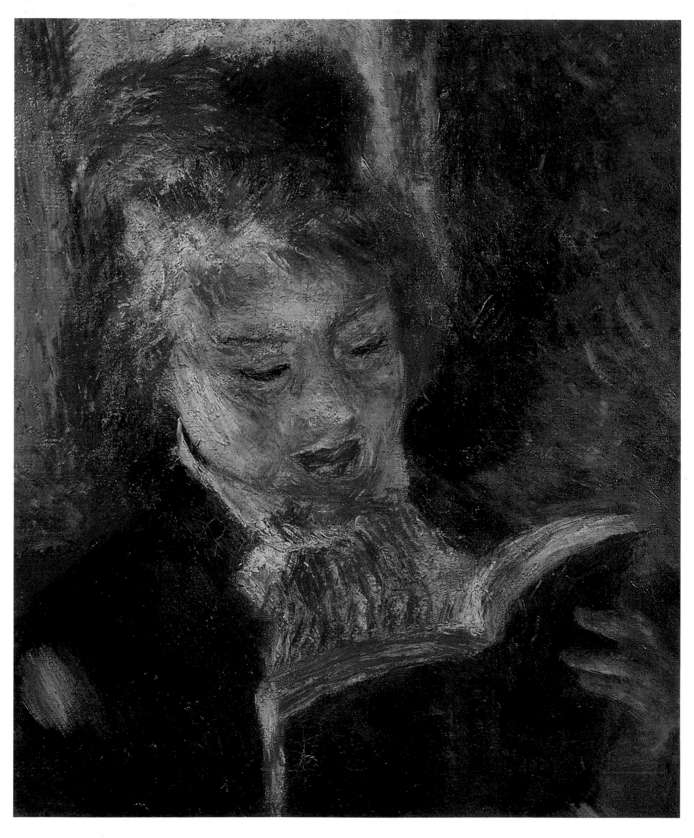

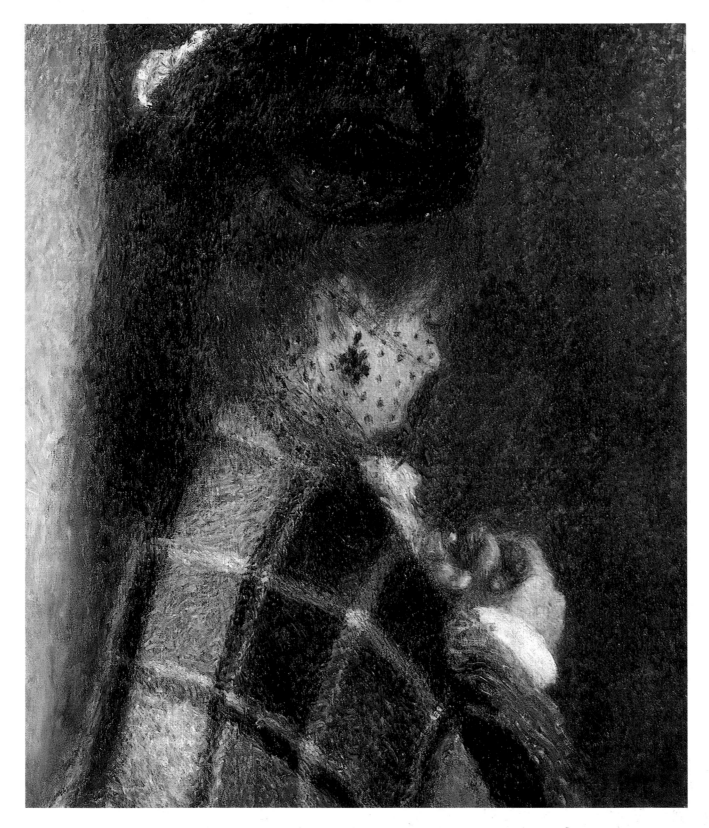

PLATE 13
**Young Woman Wearing a Veil** (1875)
Oil on canvas, 24 x 20 inches (61 x 51cm)

*One Impressionist device in portraiture was to create a casual
informality of treatment and to achieve this the painters
frequently chose to suggest that the sitter was unaware they were
being painted and even had them not looking towards the
viewer. To this extent the painting is even more typical than
the obviously posed figure in the painting opposite. The
addition of a veil adds mystery and provides an opportunity for
a dramatic opposition between the tartan geometrical check and
the small dots of the veil.*

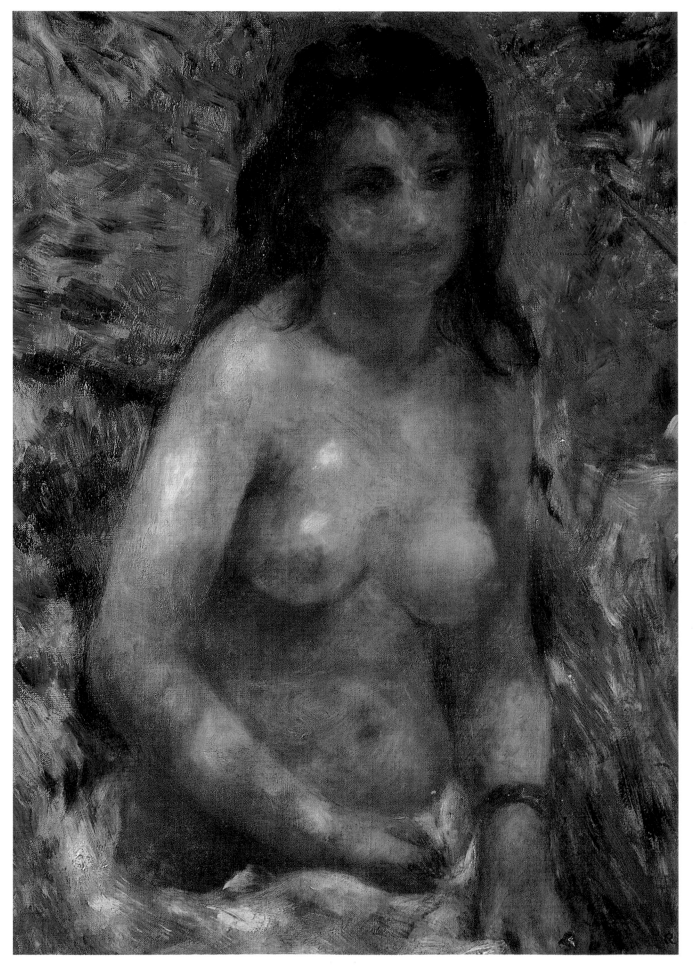

PLATE 14

## Nude Study: The Effect of Sunlight

(1875–76)

Oil on canvas, 31⅞ x 25½ inches (81 x 65cm)

*Although described as a study, this delightful work searches for an effect that is apparent in a number of Renoir's paintings of the period, including the well known* Swing *(plate 17), and* Le Moulin de la Galette *(plate 15) – the dappled effect of sunlight through foliage. In Renoir's terms, this is essentially an Impressionist painting, both in intention and treatment. The casual immediacy of the fall of light, changing on the instant, touching a small form in a passing caress, produces a strong sense of the actual visual sensation of a moment in time. The delicate brushstrokes that build the soft fleshly forms are opposed by the roughly indicated background foliage and by the sharp gold-hued bracelet and finger ring the woman wears – an acute reminder of nearby civilization ready to impinge on the idyllic scene.*

1874 at the former studio of the great early photographer, Nadar, and was called the Première Exposition de la Société Anonyme des Artistes, Peintres, Sculpteurs, Graveurs. It opened on 15 April and lasted for one month. It is now more usually known as the first Impressionist exhibition. The name Impressionist was given by a critic, Louis Le Roy, who called his highly antagonistic and sarcastic review of the show the 'Exhibition of the Impressionists' because Monet had entitled one of his paintings *Impression: Sunrise*. The name stuck and this is perhaps unfortunate since it bore little relationship to most of the work in the show, including most of Monet's. Degas, one of the organizers, preferred the appellation Independent or Realist and refused to use the word Impressionist to describe his work. In fact, the work and aims of the group were individually so different that the word Impressionist really in itself carries little meaning. Even in the case of Monet, it is only explicitly applicable for a period in the 1870s and 1880s. As far as Renoir's painting is concerned, his work is certainly close to Monet's during the Argenteuil period but, as has already been noted, Renoir was not a theorist and pursued whatever influences affected him strongly at the time, and these were numerous and with more to come.

Renoir sent seven works to this first show, including one of his much admired paintings, *La Loge* (plate 10). In this same year Renoir met Caillebotte, an amateur painter associated with the Impressionists but, more importantly for them perhaps, a sensitive collector who bought Impressionist works which later included a number of Renoir's. In the following year he met another collector, Victor Chocquet, an amateur painter and customs officer who had little money but a passion for painting, and who collected the works of Delacroix. The meeting occurred through a disastrous auction sale at the Hôtel Drouot of the works of the penurious Impressionists. The sale reflected the ridicule to which the first Impressionist exhibition had been subjected, resulting in such low prices as to seem, by today's standards, incredible. One of Renoir's paintings, *Le Pont Neuf* (1872), fetched a mere 300 francs. In another sale as early as 1910, the same work fetched almost 100,000 francs. Chocquet dropped in at the sale by chance, bought some paintings and became a friend and loyal patron of the group. Chocquet also commissioned Renoir and others in the group to paint portraits of both himself and his wife.

Renoir's Impressionism is generally held to be confined to the period from the time he was in Argenteuil, in about 1872, to the early 1880s. This is not to suggest that all works within that decade carry a specifically Impressionist character – Renoir was far too interested in exploring different methods for this to be true – but his work, together with Monet's, Pissarro's and Sisley's during the period undoubtedly have close affinities. This is

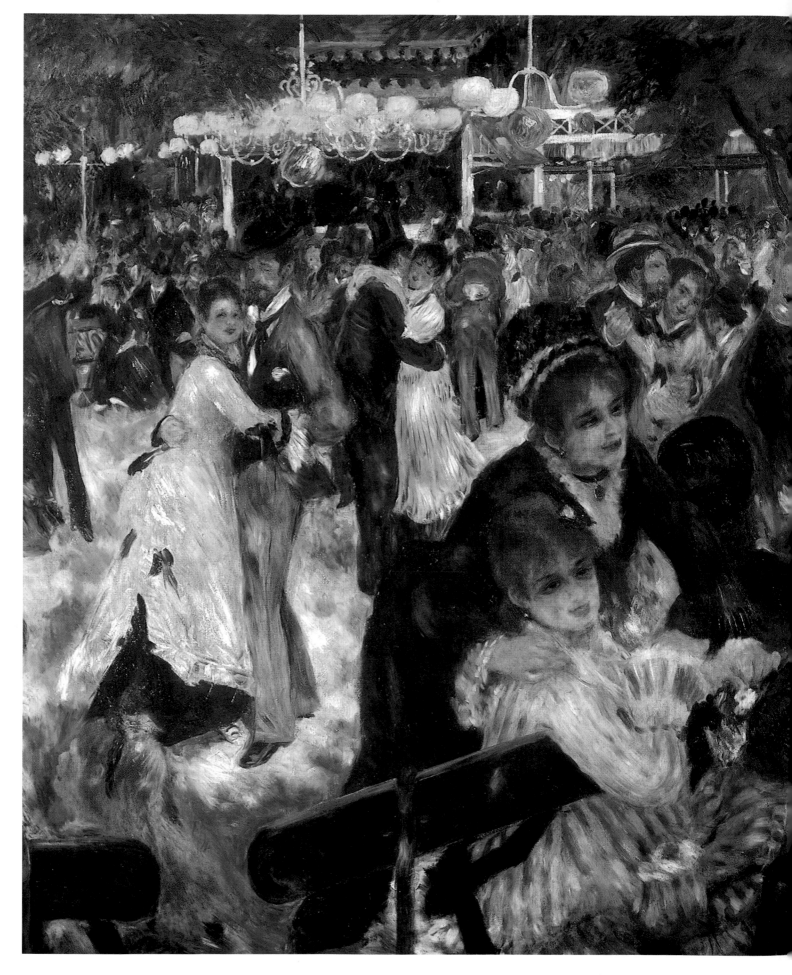

PLATE 15
## Le Moulin de la Galette, Montmartre
(1875–76)

Oil on canvas, 51¹/₂ x 68⁷/₈ inches (131 x 175cm)

*The Moulin de la Galette was one of the most popular places of entertainment in Montmartre, still then a straggling village on the outskirts of Paris and visited by the Impressionists and their friends and followers for much of the later 19th century. The Montmartre area contained a number of windmills which had fallen into disuse and had either been, like the Galette, turned into taverns, or demolished. The name derived from the speciality of the former mill, a flat biscuit-like cake known as a galette. The property was turned, first into a guinguette, a small restaurant with dancing, and subsequently grew into an open-air dance-hall and café-bar where young people of the locality, rather than high society, thronged on Sundays from 3 p.m. until midnight, in carefree pursuit of pleasure. Entertainments were provided, prostitutes danced happily when not involved in seeking clients (although even Edward, the Prince of Wales, later found a lover there), and seamstresses, laundresses, flower-girls and milliners provided Renoir and his friends with both dancing partners and models.*

*In Renoir's painting, an interesting combination of dappled sunlight and artificial illumination combine to produce a dancing confusion into which he has placed a number of his friends and their dancing partners, many identifiable through an extensive account by Georges Rivière. Jeanne, seen in* The Swing *(plate 17), is in the centre foreground with her arm over her younger sister Estelle. Since Jeanne was only 16 they clearly began to socialize at an early age. It should not be supposed that they were mostly prostitutes, they were hard-working girls, dreaming of making good marriages.*

*This is a highly considered and constructed composition, larger than most (nearly 6ft wide) and peopled with many figures. It gives an extraordinarily convincing impression of genuine enjoyment in a large gathering.*

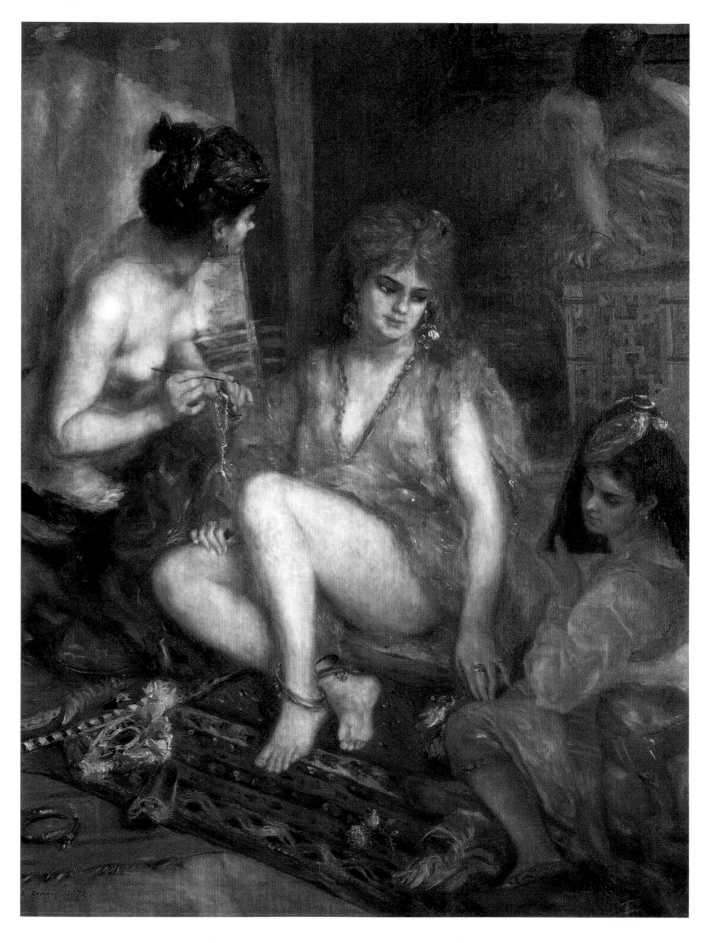

PLATE 16

## Parisian Women Dressed as Algerians

Oil on canvas, 61³/₄ x 51¹/₂ inches (157 x 131cm)

*Since the establishment of Algeria as an exotic and romantic pictorial subject after Renoir's visit there in 1833, many artists had looked to Africa and the Near East for their subject-matter and saw in his work a direct challenge to academic historicism. As a result, not only were his works and his technique copied and adopted by others, but they inspired an atmosphere of pictorial freedom which was attractive to the young independent painters who were to form the Impressionist group. Among these was*

*Renoir, always alert to possibilities of change and new directions, and he not only made copies of Delacroix's Women of Algiers but adapted the theme to something which interested him, the female form, which resulted in such curious works as the treatment opposite. The figures here are clearly Renoir's models and Parisian women in a state of undress which is a far cry from Delacroix's example. (Bared breasts and thighs are not a feature of Algerian harem life.) The two models he used are probably Fanny Roberts and Lise Tréhot already seen in plates 4 and 6. The work was painted for the salon of 1872 but was rejected which rather dampened Renoir's ardour for such foreign exoticism.*

certainly not surprising in the early Argenteuil years since the artists often painted the same subject together, views of the same skiff or the bridge at Argenteuil, for example. Renoir and Monet, for instance, painted the same view of the boating scene at La Grenouillère (plate 7), a popular venue on the Seine on the outskirts of Paris. This was also true of other locations; both Renoir and Cézanne painted Mont Sainte-Victoire together and the famous *pigeonnier* at Bellevue, Cézanne's sister's farm, with less than similar results (See plate 35).

It is indeed the diversity of the work of that small group, associated through the 1870s and 1880s and remaining friends though not always in sympathy or having appreciation for each other's work, that engages our interest. So much so, that to extend Impressionism to the last stages of the work of all of them, although perhaps with less truth in the case of Monet, is to look for an identity, a unity that did not exist and to make any such inclusivity of definition in respect of Impressionism a conjunction devoutly to be avoided. As an example: a Cézanne and a Van Gogh of 1889 can only be compared in their differences. By that year each had achieved an individual style that reflected their widely differing philosophies.

In Renoir's case, the Impressionist period lasted from about 1872, just before the first Impressionist exhibition, until 1883, when there was a dramatic change in his

technique. His life from 1872 to 1876 was difficult and, as noted, he submitted with varying success to the Salon; but he was at least helped by the support of Durand-Ruel, one of the two or three important dealers in Impressionist work who continued to purchase paintings from Renoir until Durand-Ruel himself found himself in reduced circumstances due to the failure of his bank.

During this period Renoir hoped to support himself by portraiture and in 1876 met Georges Charpentier, a liberal publisher, who commissioned him to paint Mme. Charpentier, who was herself a well known figure in the literary world, with her two children (plates 19 and 20). Through her he was introduced to the world of letters. He met such important writers as Mallarmé, Maupassant, Huysmans and, but only once, Turgenev. Although he was in a milieu that was not very much to his taste, it brought him what he desired – a number of commissions for portraits which augured well for a successful and financially rewarding career. Nevertheless, Renoir's real interests lay not in portraiture or society life and although he continued to paint portraits they were as few as were necessary to provide himself with an income.

It did not, however, prevent Renoir from maintaining contact with some of his wealthy clients. The Bérard family had a property near Dieppe and he went frequently to stay with them. In 1879 he felt sufficiently secure to marry and in 1881 made an extended trip to Italy lasting

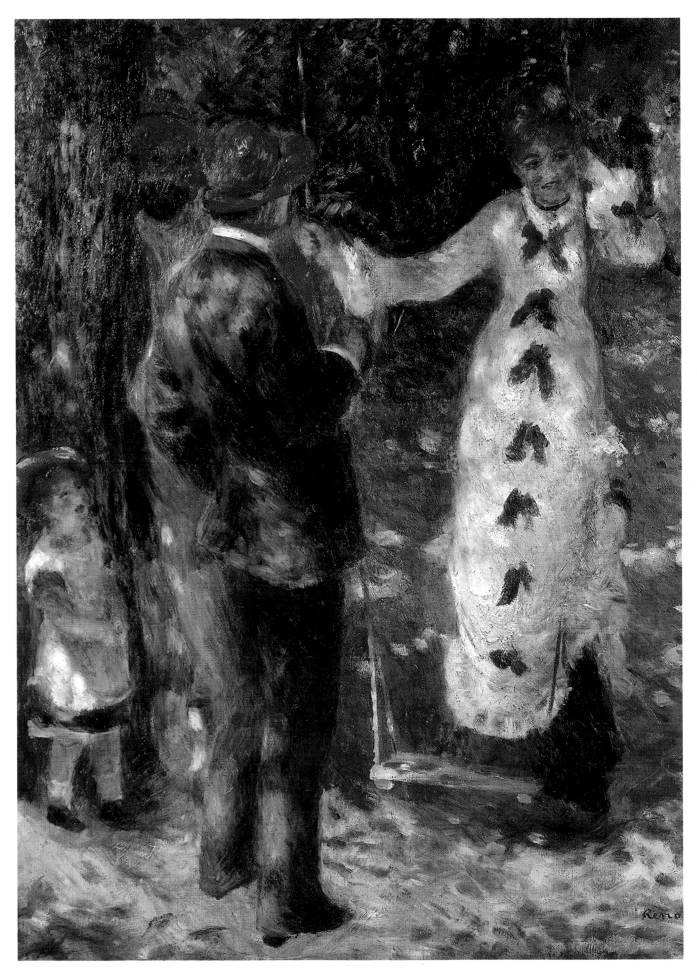

PLATE 17
## The Swing (1876)
Oil on canvas, 36¼ x 28¾ inches (92 x 73cm)

*This subject, a further study of the effects sunlight can produce, was painted around the same time as the* Moulin de la Galette *(plate 15), in the garden of Renoir's house in the rue Cortot. The woman in the swing is reported to be Jeanne, a working-class girl from Montmartre, who appears elsewhere in Renoir's work. Her two friends and the small child are unidentified. The atmosphere of uncomplicated, calm enjoyment of the sun and conversation, the privacy of the group emphasized by the distant* figures, *makes the sense of reality palpable and the Impressionist identity of the work complete. It was at this time that Renoir was at his most intensely Impressionist, both in intention and technique. It is perhaps appropriate here to note a recurrent feature of Impressionist work − the absence of a determined spatial structure. If one considers the heads of the two men, the trunk of the tree and the foliage around them, although perfectly interpretable, they are not separately and spatially identified but seen in equal relationship to the picture plane, the paint surface. In relation to academic space structure, this is a dramatic and characteristic innovation found in all Impressionists at some stage in their work.*

the whole of the second half of the year when he painted and visited galleries with his new wife, Aline Charigot. She had for some years been his mistress and model and features in a number of his paintings, including *The Luncheon of the Boating Party* (c. 1880) and some of his nude studies. In Italy he was greatly attracted by Venice and its great Renaissance painters. He also visited the galleries in Florence, although the city failed to enchant him, and in Rome visited the great Raphael Stanze in the Vatican which had a profound influence on him and which affected all his later work.

On his return from Italy early in 1882, either as a result of the influence of the works of art that he had seen there or because his restless spirit needed new fields to explore, Renoir became increasingly dissatisfied with his own painting. He visited Cézanne at L'Estaque, who was in the process of developing a new pictorial architecture, and it is possible that this too promoted the idea of search and change in Renoir's philosophy. While still in Italy, in January 1882, he had visited the frescoes in Pompeii and then gone on to Palermo to ask Wagner's permission to paint him, to which Wagner claimed that he had never allowed anyone to paint him from life. Nevertheless, he permitted Renoir to come and Wagner sat for about 20 minutes before he pleaded tiredness and withdrew. The brief unfinished sketch, and a study made from it, remain a rare record of the great composer.

During that time Renoir had became increasingly convinced that Impressionism had led him astray, that the form of classicism he had encountered in fine painting in Italy, and the qualities that he discerned in Cézanne, were the direction that his art should take. His personal Impressionism was at an end. He had not exhibited in the Impressionist exhibitions of 1879, 1880 and 1881, although he did return with 25 works for the 1882 show, among which was a painting called *The Luncheon of the Boating Party* (plate 24).

It was around this time that Renoir began to show the first signs of an illness that would eventually cripple him. On the way back from Italy, in Marseille, he had caught a cold which turned to pneumonia, but on a doctor's advice had made a second visit to Algiers. On his return, he painted steadily for an exhibition arranged for April 1882 by Durand-Ruel and showed 70 works covering his painting career from 1870. The exhibition established his reputation and assured him that, provided he continued his Impressionist works, he had no need for concern for his financial future. Characteristically, it was at this point that Renoir abandoned Impressionism. At the end of 1883 he told Ambroise Vollard, dealer and friend of the independent group: 'I had come to the end of Impressionism and had arrived at a condition in which I did not know how to paint or draw. In a word, I was at an impasse.'

PLATE 18
**Les Grands Boulevards** (1875) below
Oil on canvas, 20½ x 25 inches (52.1 x 63.5cm)

*The effect of Baron Haussmann's rebuilding of the centre of Paris, which included wide boulevards and large classical avenues of architecture, was to create an open city with streets lined with trees, illuminated in the wider spaces provided by the boulevards by full sunlight. It is a scene that Renoir has painted in a full Impressionist work, using the trees both as a source of vibrant colour and disguising the monotony, as Renoir saw it, of long classical façades.*

PLATE 19
**Madame Charpentier** (1876–77)
Oil on canvas, 18 x 15 inches (46 x 38cm)

*Georges Charpentier, soon after his meeting with Renoir, commissioned this rich and attractive portrait of his wife which in turn led the large painting of Madame Charpentier and her two children (plate 20). Renoir's intention of becoming a portrait-painter was much advanced by his contact with the family as Madame Charpentier was a noted society hostess who introduced Renoir to a number of important clients. That his inquisitive spirit led him in different directions is a characteristic of his life and the nature of his painting.*

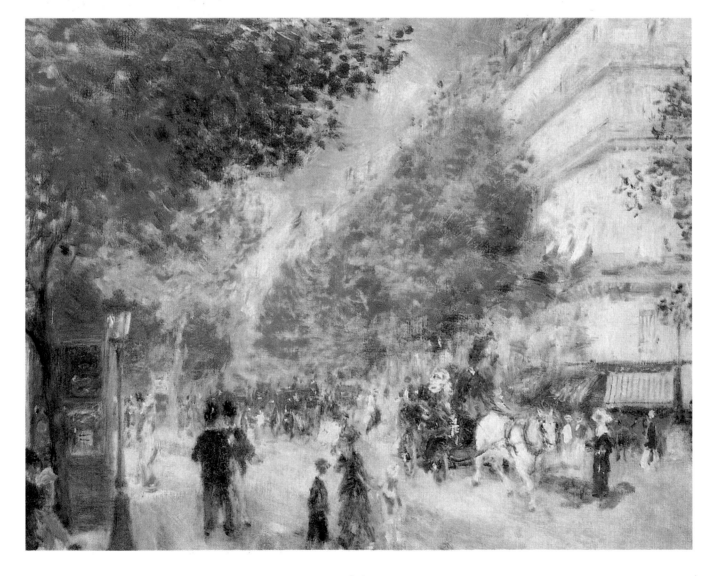

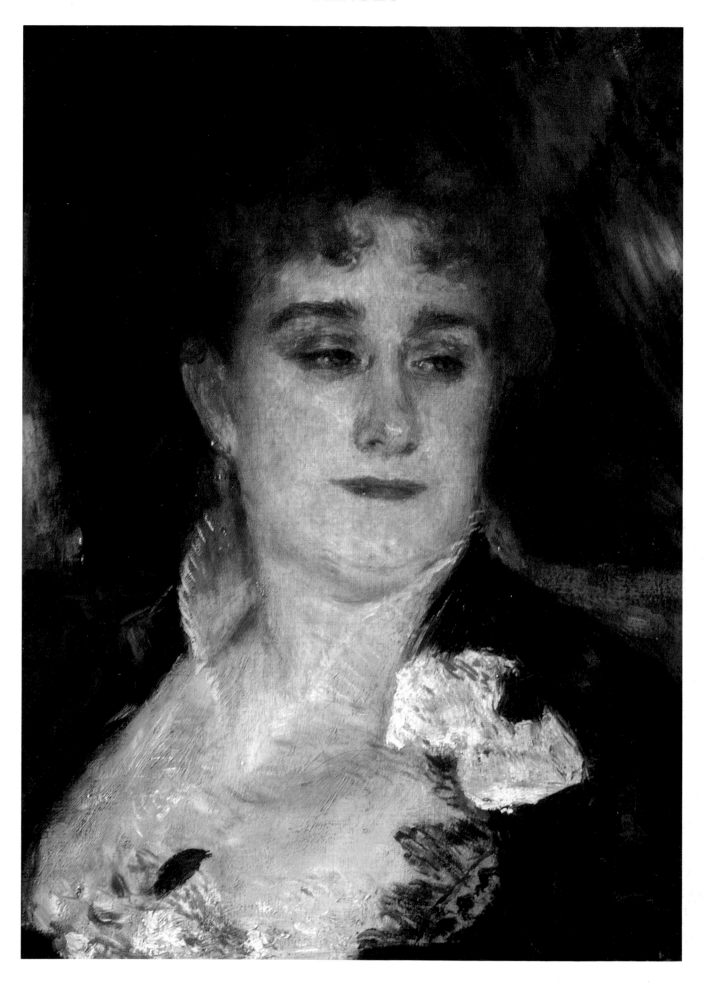

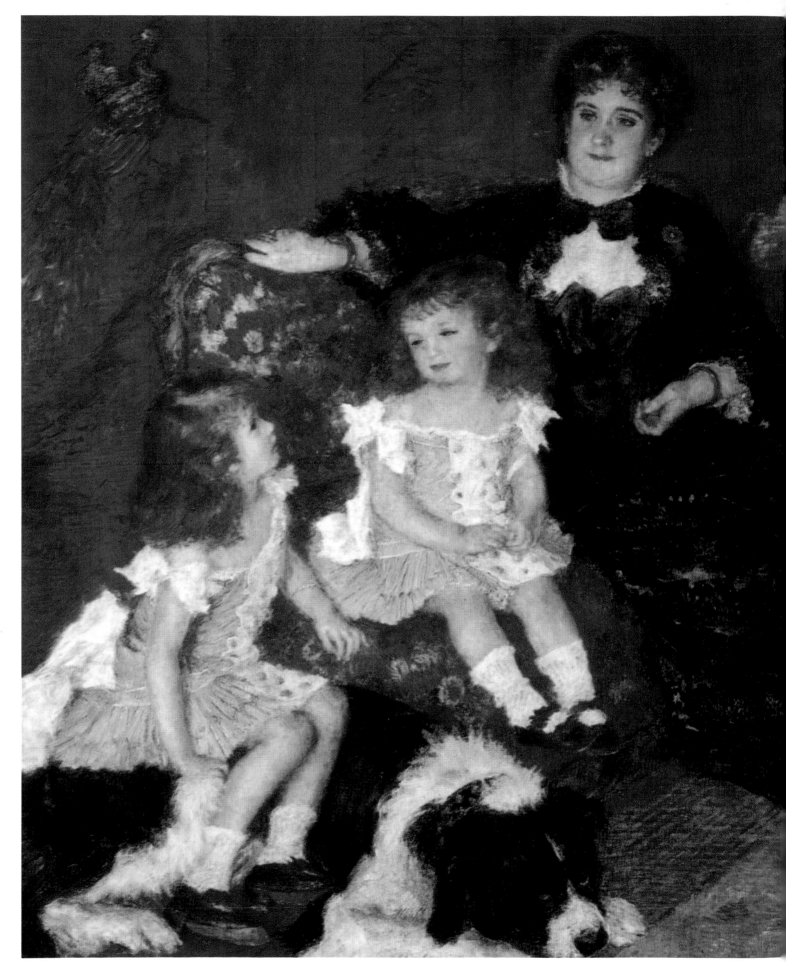

PLATE 20

## Madame Charpentier and her Children
(1878)

Oil on canvas, 60²/₃ x 75 inches (154 x 190.5cm)

*Renoir's meeting with Georges Charpentier, a successful Parisian publisher, seemed especially fortuitous since at this period in his life he was intending to become a portrait-painter as a way of making a living. He had already made a portrait of Jeanne Samary (plate 21), a well known actress and this, together with the commissions he received to paint members of the Charpentier family, set him well on the way to becoming a successful portraitist. He met Charpentier in 1876 and during this year or early in the next completed a strong and sympathetic portrait of Mme. Charpentier (plate 19). His use of deep-blue and near-black as a foil to the delicate colour and sensitive drawing of the head gives this work an air of authority and distinction which must have encouraged this larger commission for the mother with her children. Renoir did not show in the Impressionist exhibition of 1879, nor in the two following, but he was accepted for the Salon of 1879 with both the Samary and Charpentier family portraits.*

*Although there is the intimate air of a united family about the group painting, there are also the studied poses of the mother and children which were more academically acceptable to the Salon than to the independents of the Impressionist group. Had it not been for Renoir's own independent spirit of enquiry and experiment he might have developed into an effective portraitist but not the great master he was destined to become.*

PLATE 21
## Portrait of Jeanne Samary (1878)
Oil on canvas, 68 x 40½ inches (173 x 103cm)

*This delightfully elegant portrait of a well known actress (who had also acted before as his model) was another of the paintings Renoir undertook, partly to encourage custom for the portraits from which he hoped to make a living. There is a pleasant frankness in the contrast of a figure who could well be a member of a higher social class and the insouciant freshness of a person who is a stage performer with all the implications associated with the profession at that time. Simultaneously both formal and informal, it already indicates that Renoir was right to expect a successful career as a portraitist. His portraits of both Jeanne Samary and Madame Charpentier and her children (plate 20) were accepted for the 1879 Salon.*

During 1881 Renoir had painted a number of nudes and landscapes which presaged his conversion to a classical linear style, sometimes called his 'sharp' or 'harsh' period. Among these paintings is a seated nude bather which is an evident mixture of linear and Impressionist elements. Like many of such studies it is of his wife.

The year 1884 saw the avant garde's dismissal of both the realist tradition and Impressionism for the beginning of the next generation of young painters who, in May, and calling themselves 'Le Groupe des Indépendants', organized an exhibition. Although it was not successful and attracted little attention, it included work by Seurat and Signac who subsequently organized a new group, the 'Société des Artistes Indépendants', continuing the theme proposed by Degas for the first Impressionist exhibition and holding their first show in December. It was the beginning of the succession of movements which occurred from then until the 1930s throughout Europe. Not only had Impressionism been superseded but it was also old-hat – a new academicism. The Impressionist painters had ceased to be members of the avant garde and were now masters whose work was collected, whose prices correspondingly rose, and each of them now individually pursued their own solutions.

There was no Salon des Indépendants in 1885, but the following year the Seurat group held the second Salon des Indépendants and, symbolically perhaps, 1886 also saw the last, and eighth Impressionist exhibition take place. Organized by Berthe Morisot in consultation with Degas, it was simply called the '8ième Exposition de Peinture', at his insistence. He had never wished their exhibitions to be called *impressioniste*, preferring instead *indépendant*, but was pre-empted at the end by the up-and-coming generation.

Renoir's contribution to this new stage in the history of 19th-century French art was not inconsiderable. We have already noted a new linear structural basis to his painting of the nude bather. Another well known painting of this time is *Les Parapluies* (plate 32), in which elements of both his new linear and old Impressionist style are present; the new linear in the figure on the left and the old Impressionist in the figures on the right. The *Grandes Baigneuses* (plate 34) of 1887 represents the full expression of Renoir's linear, classical style as it had developed. If it is compared with the *Moulin de la Galette* (plate 15) of ten years earlier, his pictorial development from Impressionism is evident. Of course it will come as no surprise to learn that, having come to terms with and even shown enthusiasm for Renoir's 'Impressionism', both public and critics took his pictorial recidivism as a personal insult and were dismayed by the sharp coldness of his new direction. It was not until the earlier years of this century, when his whole work could be viewed, that his adventurous independent spirit could be fully appreciated.

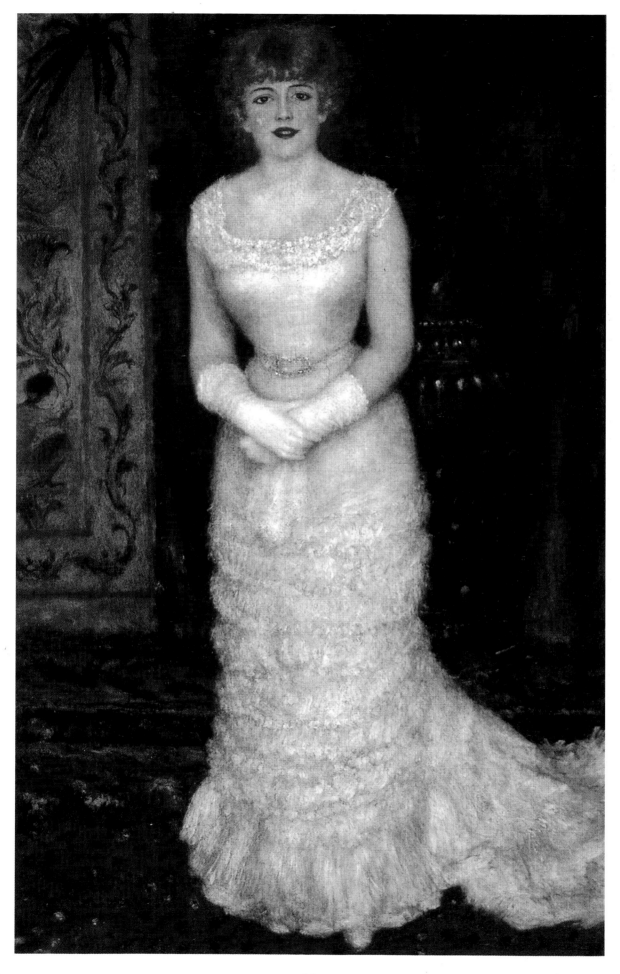

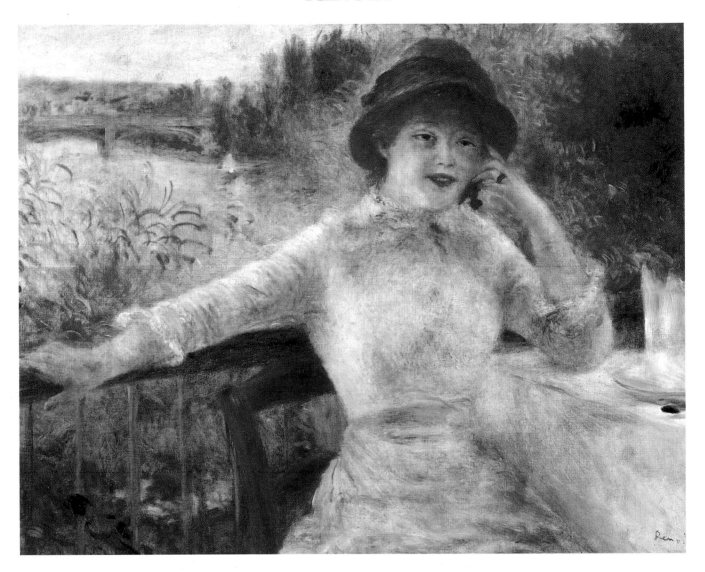

PLATE 22
## Portrait of Alphonsine Fournaise (1879)
Oil on canvas, 19²/₃ x 15³/₄ inches (50 x 40cm)

*The daughter of the proprietor of the Restaurant Fournaise, the location for the* Luncheon of the Boating Party (plate 24), *is the subject of this painting which includes a view along the Seine from the same balcony towards the rail bridge at Chatou. Originally it was thought to have been La Grenouillère. The rail bridge is yet another reference to the importance that all the Impressionists attached to the ubiquitous industrial development as an expression of modern civilization.*

But the stylistic changes were not yet over. Renoir returned for a time to his earlier Impressionist technique at the beginning of the 1890s, having realized that the harsh linear style did not really express his intention and during the decade a more luminous, softer feeling began to emerge in his painting, the expression of the contained volume being maintained but without clear linear definition. His subjects included landscapes, young girls – clothed and nude – and portraits of his family. His great friend Gustave Caillebotte died in 1894, leaving Renoir as his executor to arrange for Caillebotte's bequest of his collection to the nation to be accepted by the Louvre. The officials of the École des Beaux Arts, still suspicious of the new developments in painting and anxious to maintain their authority, refused to accept them. As a result, Renoir was obliged to spend much time and energy in tiresome bickering. In the end he was only partially successful, and 65 works were eventually accepted.

The late 1880s and early 1890s were an indeterminate

PLATE 23
## Portrait of Stéphane Mallarmé (1824–98)
Oil on canvas, 19²/₃ x 15³/₄ inches (50 x 40cm)

*Mallarmé was one of the important literary figures of 19th-century Paris, a poet and prose writer with a considerable reputation. He was a contemporary of the Impressionists, a close friend of Manet, Degas and Renoir and a strong apologist for the movement. He earned his living teaching English in various schools in Paris; while teaching at the Lycée Condorcet, he called on Manet every day. Mallarmé became an influential figure, not only through his writings, but also through the Tuesday soirées held at his flat in the rue de Rome where most of the Impressionists forgathered at one time or another. His eclogue,* L'après-midi d'un faune, *inspired Debussy's prélude. Mallarmé's poetry reflected a belief that it alone provided an authenticity to life on earth – the only reality (a theme later developed by the Existentialists) being the one in which one lives. This was a notion that was in sympathy with the Impressionist aim of immediacy of vision. The painting itself is a study in a style that succeeds Renoir's Impressionist period.*

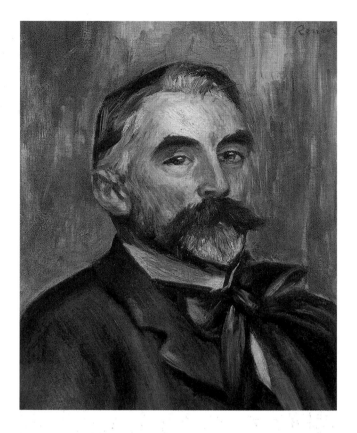

period for Renoir. His first son, Pierre, born in 1885 and his second, Jean, born in 1894, both became subjects of his painting as had been, and still was, Renoir's wife, Aline. He also painted a number of landscapes both in northern and southern France. In retrospect, it seems as though Renoir had not decided on a new direction but was exploring whether there were any possibilities in what he had already produced. Also, what had already been threatened was becoming a reality; he began to suffer attacks of arthritis in 1894.

The onset of what was to become a serious disability and which was to greatly inhibit the continuation of Renoir's painting programme resulted in his decision, in 1903, to move the family to Cagnes-sur-Mer on the French Riviera where he bought a house and land in 1907, Les Collettes. There were times when he was unable to paint and was eventually to spend much of his time in a wheel-chair when his brushes had to be strapped to his hand. By 1912, he was partly paralysed. His third son, Claude (Coco), had been born in 1901 and quickly became another subject for this his late style.

It might be expected that as a result of his illness the major achievements of his painting would be over. Nothing could have been further from the truth because it is now recognized that when all the stress and soul-searching was over, when his energies had to be carefully husbanded, his experience, technique and range supported

him in a last great period of nudes and bathing groups which put him among the young moderns of the 20th century. He died in Cagnes on 3 December 1919.

It should be noted that in his last years, with the aid of assistants, Renoir created some sculptures of which a large nude, *Venus*, is his best known. Much like Degas, who was at the same time suffering from a serious and continuing deterioration of his sight, Renoir turned to sculpture when he was hardly able to control his painting hand and, with the aid of assistants who modelled the clay to his directions, created a number of important works. Like Degas, his subjects were his own personal favourites, members of his family and nudes. It is interesting to note that he called what is actually a standing nude study, *Venus Victorious* (plate 45) – an indication of the continuing classical identification intended to gain credibility with the academics; underlying Renoir's independent spirit there always remained a perhaps grudging, but nonetheless real respect for the Salon.

A study of the illustrations in this book will indicate the variety of styles and variations in quality of Renoir's *oeuvre*. There is no doubt that he was an important and influential Impressionist painter, responsible not only for some of the most memorable works of the movement, but was also an exploratory painter for whom Impressionism was not enough. Since Renoir lived into this century, with

*Continued on page 53*

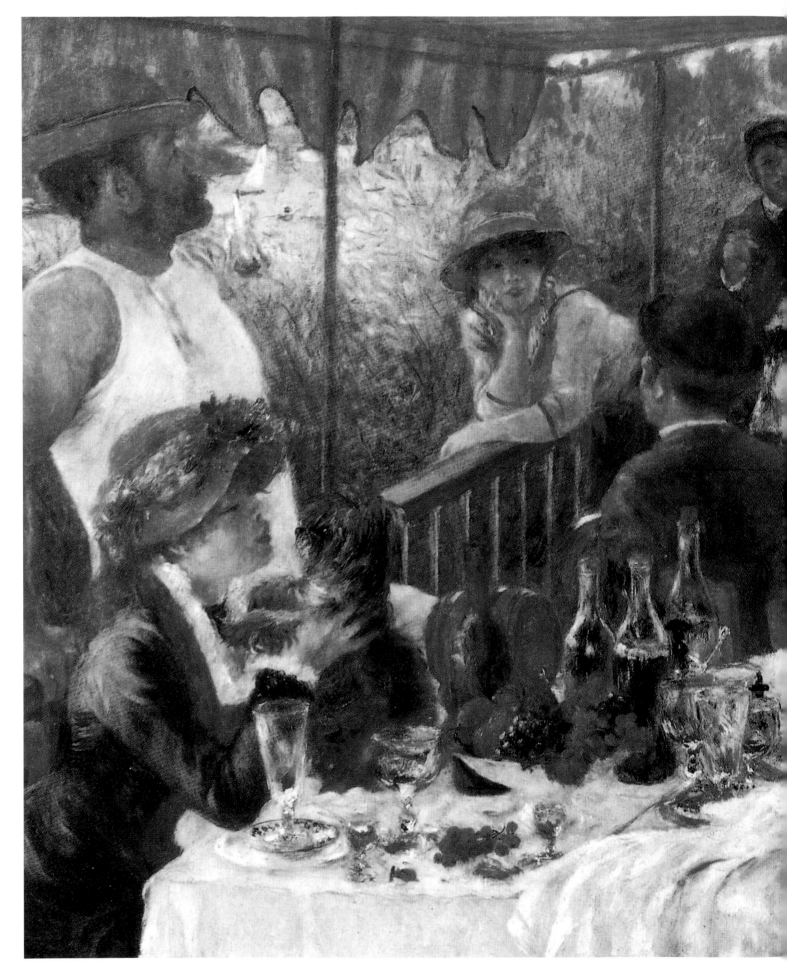

PLATE 24
## The Luncheon of the Boating Party
(1880–81)
Oil on canvas, 51¼ x 68 inches (130 x 173cm)

*As with* Le Moulin de la Galette *(plate 15) and others,*
*Renoir painted works which summarized his attitude, even*
*encapsulated it at various stages of his career in major*
*representative works, in* tours de force, *and this painting brings*
*Renoir's Impressionist period to a close. The painting is located*
*on the first-floor balcony of the Restaurant Fournaise overlooking*
*the Seine on the island of Chiard, near Chatou, and was a*
*favourite meeting place for boatmen, poets and intellectuals.*
*Although the Impressionist method and treatment was not lost to*
*Renoir and appeared later on different occasions, the specific*
*identification was at an end. As usual, some of Renoir's friends*
*are among those depicted and a model, soon to become his wife,*
*Aline Charigot, is seated to the left with a little dog looking*
*remarkably like the griffon in an earlier work (plate 6). The other*
*girl at the table is another favourite model, Angèle, of singularly*
*colourful reputation and Caillebotte sits astride the chair in the*
*foreground. Renoir confessed to having contemplated the subject*
*for some time and although he was just 40 claimed, 'I am not*
*getting any younger and did not want to put off this little feast.'*
*It is almost a statement of projected change. It is likely that the*
*design was made during the summer of 1880 while Renoir was*
*staying with Mère Fournaise at Croissy. He exhibited the work*
*at the seventh Impressionist show of 1882 after a gap of a*
*number of years.*

*    The composition is an interesting balance between the two*
*halves created by the diagonal from bottom left to top right. Most*
*of the figures are concentrated in the lower half and a vista is*
*pierced through the foliage in the upper, while the striped awning*
*holds the eye within the picture. Although the figures are tightly*
*packed, they appear to recess comfortably into the near distance;*
*but it may noticed that to contrive this, Renoir has given the near*
*table a lower eye-level than the other, thus allowing more to be*
*seen of the background. The varied twisting turns of the figures*
*within this structure reveal Renoir's pictorial maturity. While not*
*as well known as the* Moulin, *this is another undoubted*
*masterpiece.*

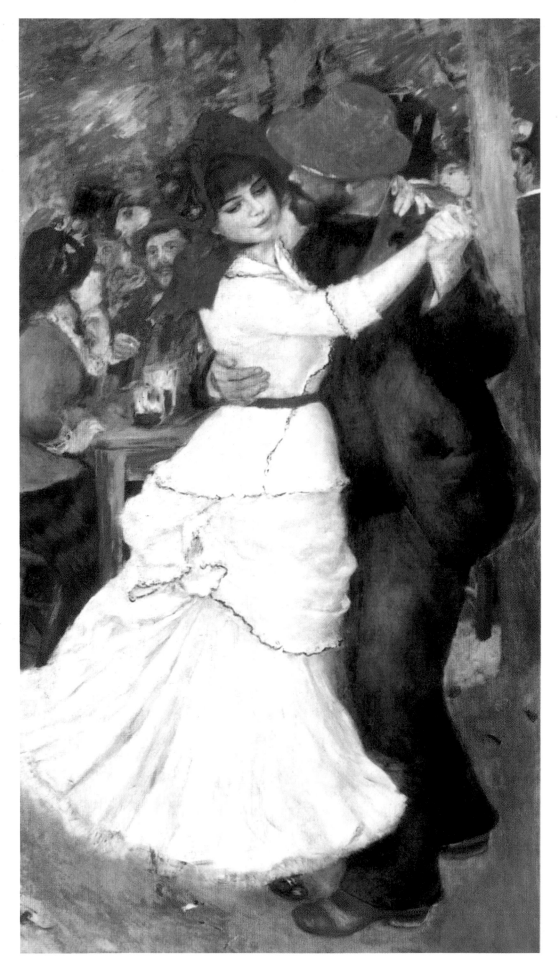

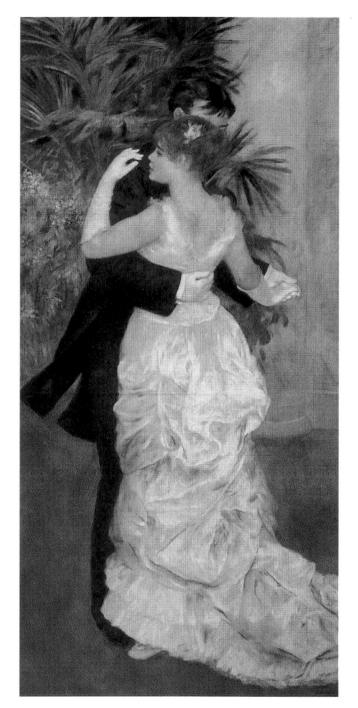

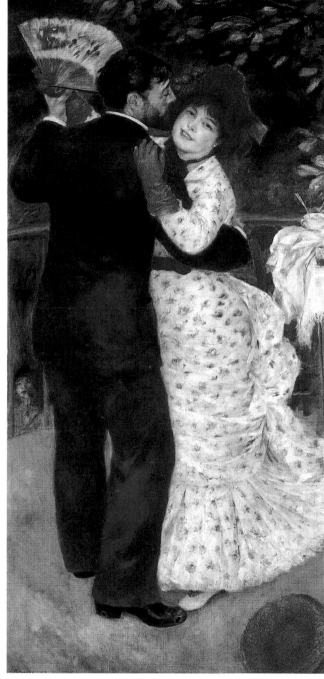

PLATE 25

**Dance at Bougival** (1882–83) opposite

Oil on canvas, 71²/₃ x 38¹/₂ inches (182 x 98cm)

PLATE 26

**Dance in Town** (1883) above

Oil on canvas, 70⁷/₈ x 35¹/₂ inches (180 x 90cm)

PLATE 27

**Dance in the Country** (1883) above right

Oil on canvas, 70⁷/₈ x 35¹/₂ (180 x 90cm)

Dance in the Country *is a large vertical canvas, almost life-sized, and one of two panels Renoir painted as companion pieces, the other being* Dance in Town. *A third painting,* Dance at Bougival, *completes three studies of dancing in different moods. The third looks back to the boating scene while the other two seem to be designed as decorative panels in a new and harder linear style, presaging a new 'harsh' method which Renoir developed for a short period. The male model for all three paintings was his friend Paul Lhôte and the girl in the country and town panels was Maria Clémentine who later became a well known painter, Suzanne Valadon, and the mother of Maurice Utrillo.*

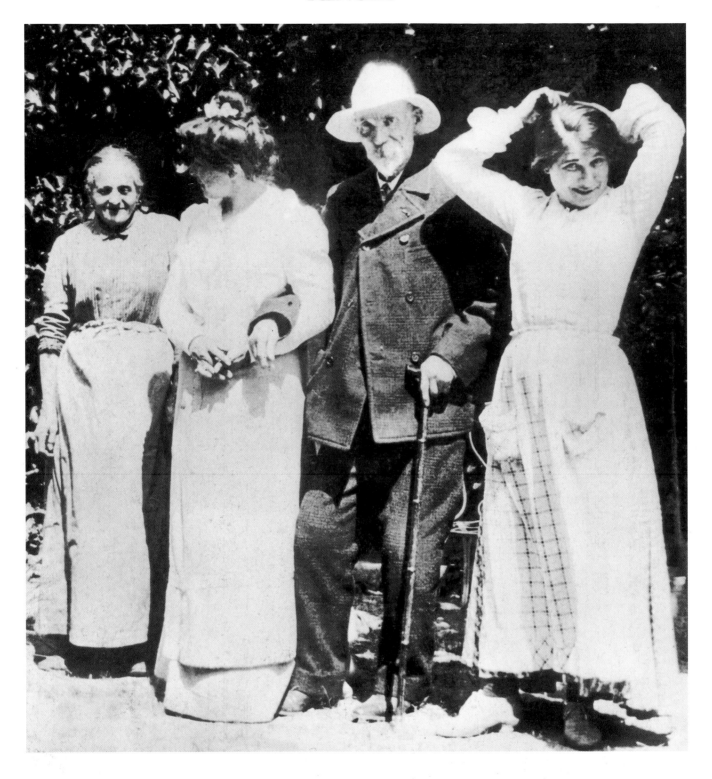

PLATE 28
**Renoir with his family**

PLATE 29 opposite
**Renoir at work in his studio with model**

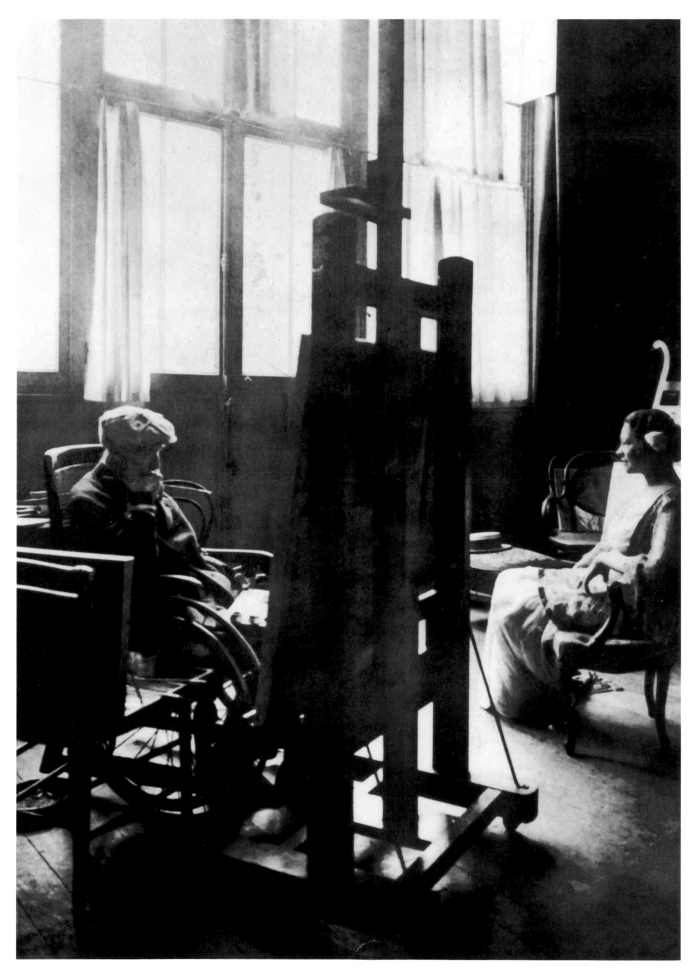

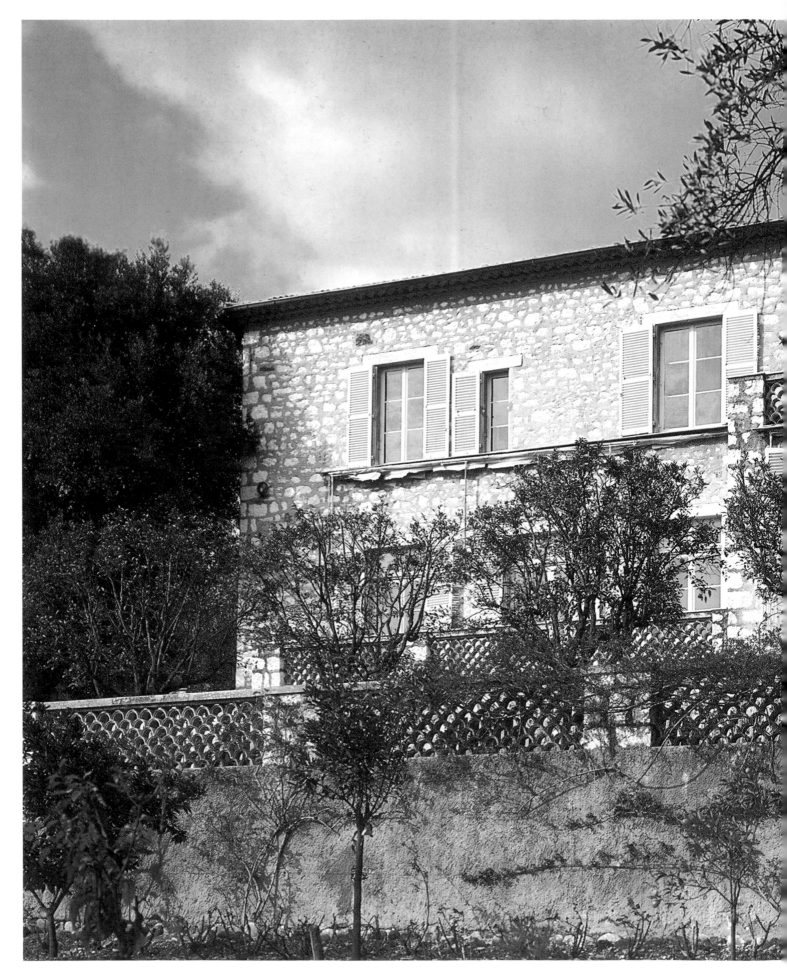

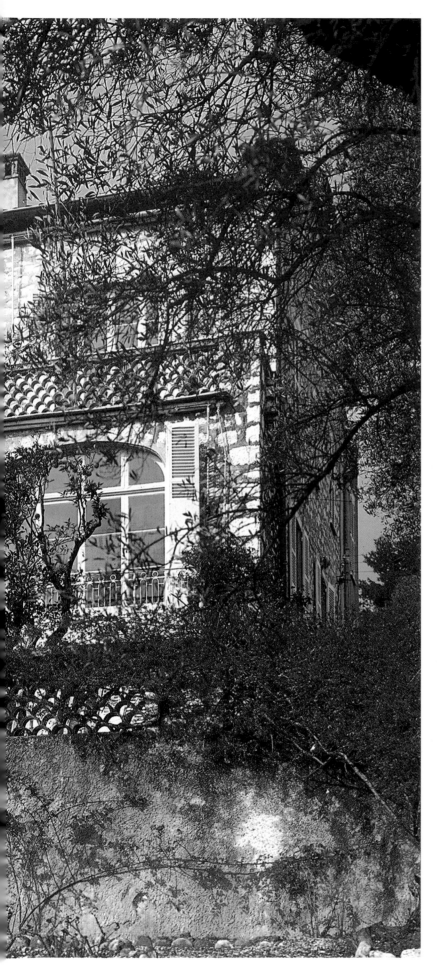

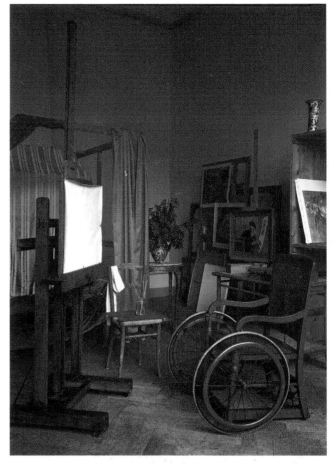

PLATE 30 left

**The exterior of Renoir's house, Les Collettes, at Cagnes-sur-Mer, photographed in 1908**

PLATE 31 above

**Renoir's studio, showing his easel and wheel-chair**

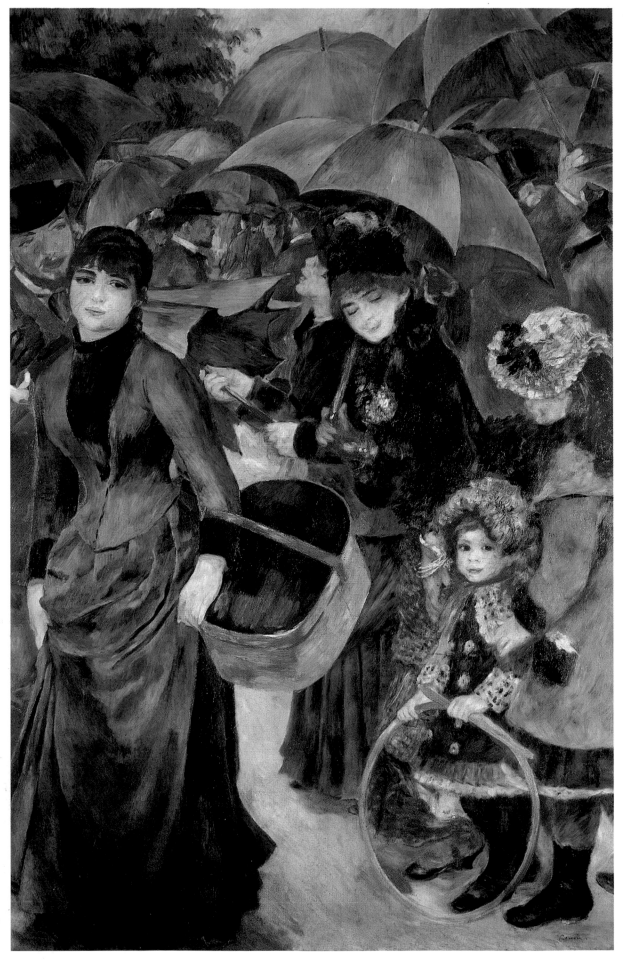

PLATE 32

**Les Parapluies (Umbrellas)** 1881–86) opposite

Oil on canvas, 70⅞ x 45¼ inches (180 x 115cm)

PLATE 33

**In the Luxembourg Gardens** (1883) below

Oil on canvas, 25¼ x 20⅞ inches (64 x 53cm)

*Renoir's independence of mind, mentioned a number of times, had always prevented him from being irrevocably locked into the Impressionist mould and after 1880 he was in search of a new range of expression, influenced by visits to Cézanne, the south of France, Algeria and Italy – notably to Venice. The* Umbrellas, *begun in 1881 and painted over a period, coincided with the beginning of a change and the painting clearly reveals this. One element in that change was that Renoir decided to work mostly in the studio rather than* en plein-air, *describing outdoor painting as too complicated, demanding constant compromise, and this painting – a dense grouping of figures – was obviously not only an opportunity to work in his studio but almost a necessity. The result, over the time it took to paint it, is a mixture of mainly Impressionist methods on the right, particularly the child with the hoop and her family, and the strongly defined figures on the left-hand side. So clearly are forms drawn that voids become solids, as in the interior of the basket or the undersides of the umbrellas. It is the beginning of the so-called 'harsh' style of defined form and carefully gradated colour areas. There is, for instance, in the two little girls on the right a softness and charm not evident in the girl with the basket.*

*The small study* In the Luxembourg Gardens *painted at that time is also clear evidence of the struggle for a new development that Renoir was undergoing at the time. Rather than a single unified composition, it is a group of episodes related to the major work and suggesting that the larger work is located in the gardens.*

*Continued from page 43*

a growing reputation, his influence on the early 20th-century pictorial philosophy is significant, particularly his later work which perhaps not surprisingly follows something of a similar course to that of his longer-living contemporaries, Degas and Monet. Monet, like Degas, almost lost his sight in his later years, and the work of the three painters all showed an inevitable loss of detail and physical precision in their last years; but their knowledge, experience and determination meant that they could still produce work of the highest sensitivity, transcending their physical disabilities. Monet was a difficult man in his later years, a recluse and a domestic martinet. Degas also became reclusive, his sharp tongue and reserved nature a vestige of the way he viewed his position in society, and always setting him apart. He was not a convivial person.

But Renoir was different. His was a kind, generous and happy nature, rooted in a typically French artisan/bourgeois character – what might be described as a nice man. An appropriate anecdote ends his story. He was once asked to confirm that a painting ascribed to him was a forgery in order that the forger might be convicted. On learning that the man was wretched and destitute, he painted over the picture, thus authenticating it and saving the man from prosecution.

It is possible with Renoir's work to divide it into the periods of stylistic change, since these changes were relatively dramatic and hence identifiable. They are: the early years; the Impressionist period; the sharp/harsh period; the radiant/iridescent period; resolution at Cagnes.

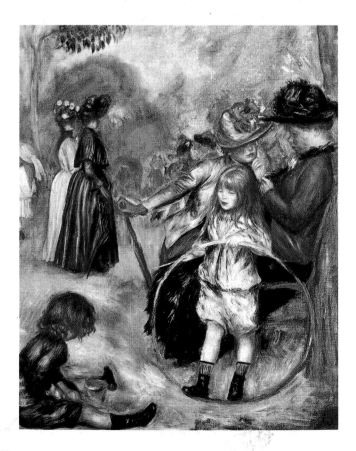

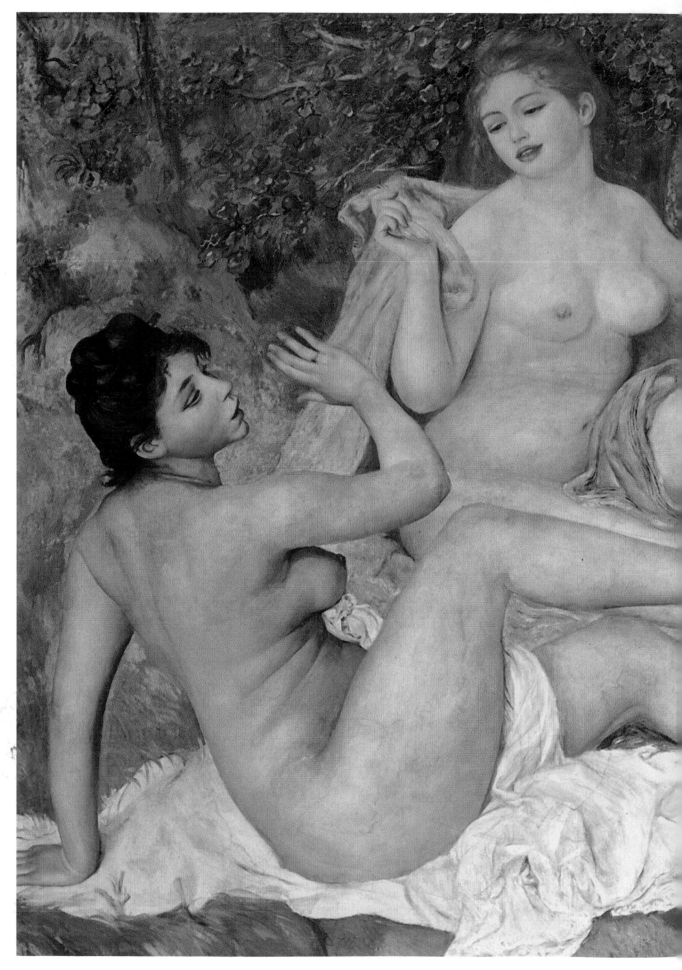

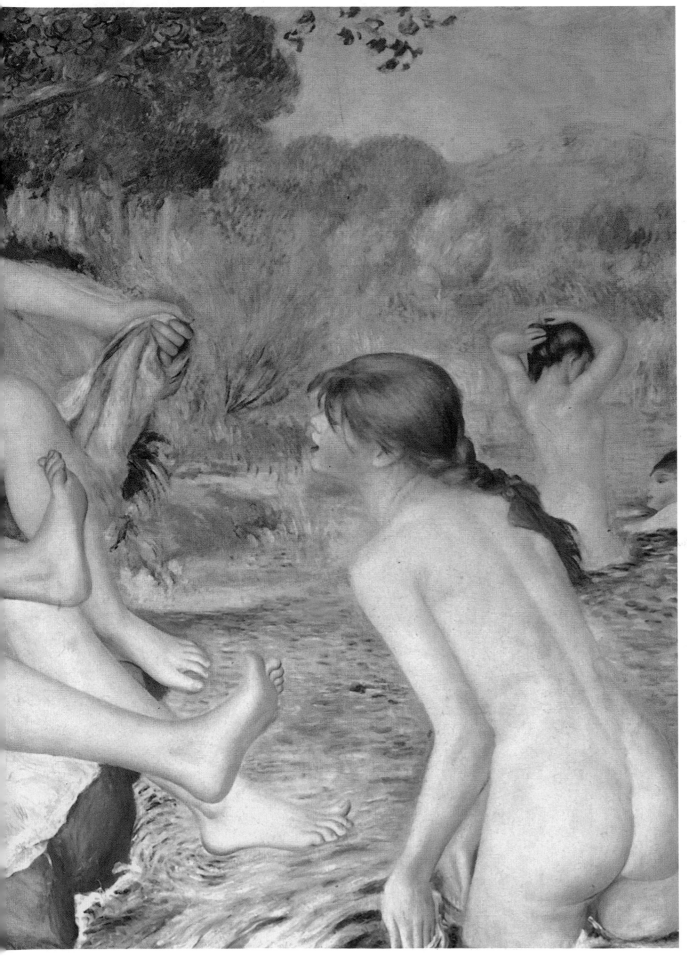

PLATE 34
## Les Grandes Baigneuses (The Bathers)
(1884–1887) previous pages
Oil on canvas, 45¹/₂ x 67 inches (116 x 170cm)

*Renoir worked on this subject over a period of two or three years making many studies, sketches of details, and changes in composition in preparatory versions. Some of the figure studies he made became individual works. Many influences can be discerned in this work: the classical inspiration led him to Ingres and Raphael (whose work he had admired in Rome) and the clarity of fresco and its simplicity of paint and colour. The lively poses were derived from Girardon's work at Versailles. However, the spirit of the work is essentially Renoir and the style 'harsh' – his période aigre masterpiece. Renoir made the following comments: 'After three years of experimentation, The Bathers, which I considered my master-work, was finished. I sent it to an exhibition – and what a trouncing I got! This time, everybody, Huysmans in the forefront, agreed that I was really sunk; some even said I was irresponsible. And God knows how I laboured over it.' Perhaps he should not have been surprised: when people do the unexpected they are often thought to have gone off the rails! But different as it is from Renoir's previous Impressionist work, it is nevertheless a great creative expression of classical* joie de vivre.

PLATE 35
## Montagne Sainte-Victoire (1889)
Oil on canvas, 20⁷/₈ x 25¹/₄ inches (53 x 64.1cm)

*During Renoir's travels in 1889, he rented a house in Aix-en-Provence belonging to Maxime Conil, Cézanne's brother-in-law, and with Cézanne painted the same subjects from the same viewpoint at the same time. The tight architectural structure of Cézanne's painting of one of his favourite subjects, the dominating form of the great mountain, is not however repeated in Renoir's version which carries residual evidence of Impressionism but in which the forms are more volumetrically constructed than they would have been during his Impressionist period.*

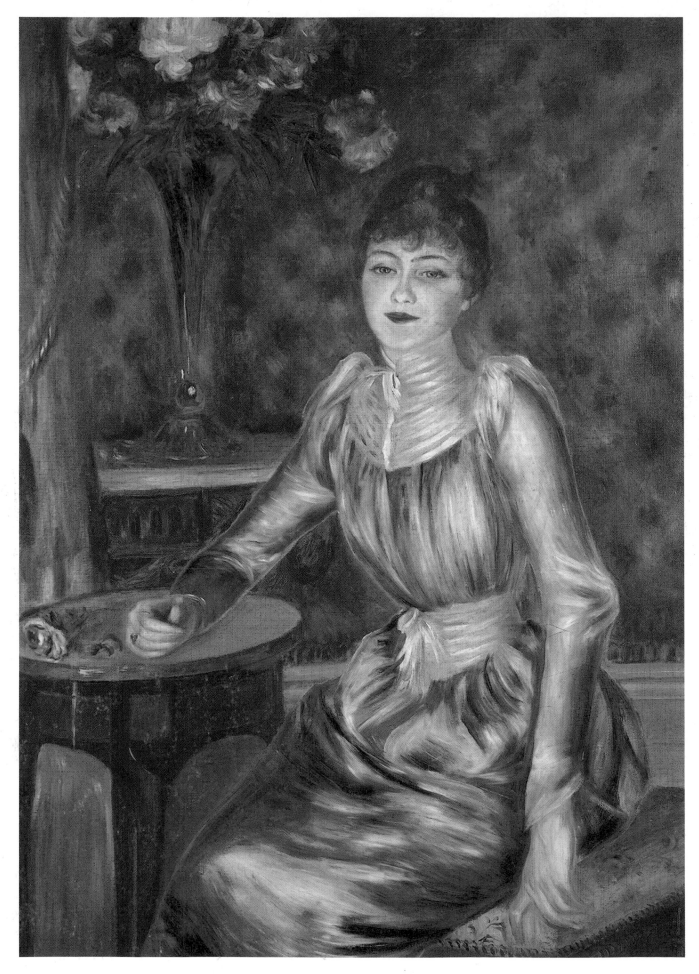

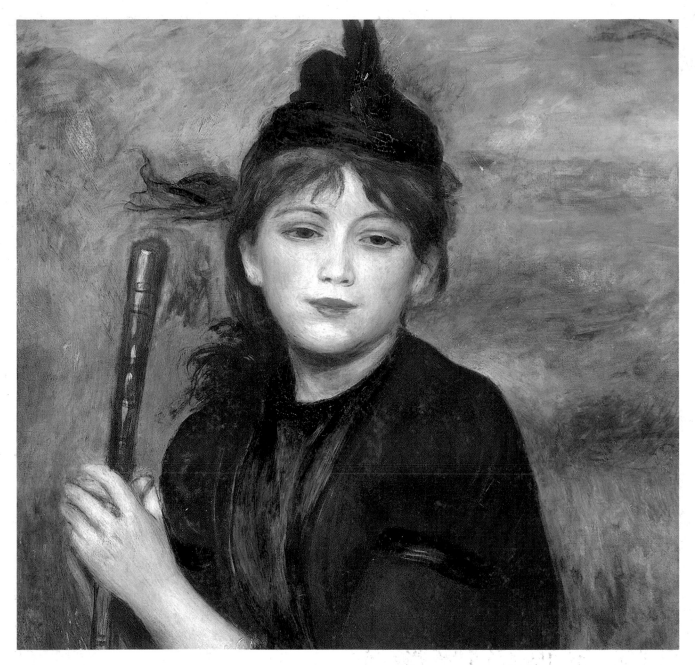

PLATE 36
**Madame de Bonnières** (1889) opposite
Oil on canvas, 46 x 35 inches (117 x 89cm)

*A delicate but unconvincing portrait with less than accurate
drawing, this seems to be more of an uninvolved portrait
commission which reveals how difficult portraiture can become
when all the abilities and sympathies are not totally engaged.*

PLATE 37
**The Rambler** (1895) detail
Oil on canvas, 24 x 19²/₃ inches (61 x 50cm)

*When clearly engaged and enthusiastic, Renoir is likely to bring
power and originality to an open-air subject, even when using a
model who has in all probability hardly set foot outside
Montmartre and has been painted in a studio. This work was
completed after both the Impressionist and 'harsh' stages in
Renoir's career and shows an engaging assurance, needing only a
vague sense of the open-air in the background and a strong
walking-stick to establish the subject. The firmness and clarity of
the drawing show Renoir in his maturity before physically
afflicted when in 1888 his face became partially paralysed and
made firm linear painting excessively and progressively difficult.*

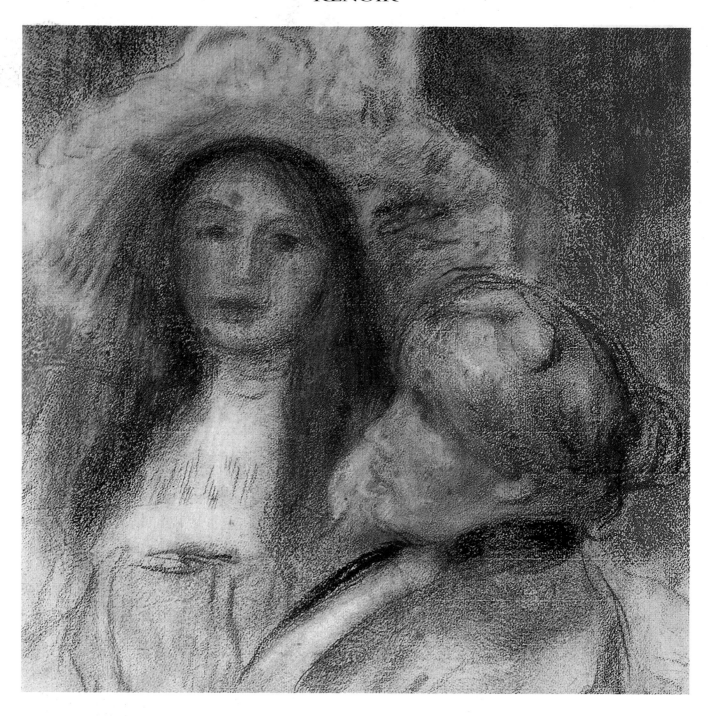

PLATE 38
**Berthe Morisot with her Daughter**
(1894) detail
Sketch in pastel, 23¹/₄ x 17⁷/₈ inches (59 x 45.5cm)

*Berthe Morisot (1841–95) was one of the most intelligent and talented of the Impressionist group. She was greatly admired by Renoir who painted her a number of times. After her early death at the age of 54, her daughter, Julie Manet, became Renoir's ward.*

PLATE 39
**Bather with Long Hair** (c. 1895) opposite
Oil on canvas, 32¹/₄ x 25¹/₂ inches (82 x 65cm)

*Comparison of this painting with* Les Grandes Baigneuses *(plate 34) indicates that Renoir had abandoned his 'harsh' style for a more delicate and, in some ways, Impressionist method. Edges are no longer sharply defined and the forms are fully rounded with a sympathetic painting of flesh in Renoir's highly personal technique. The vague indication of location – foliage and water means bather – concentrates the attention on the young and rounded nude figure which Renoir delighted in painting, often using the same model for different paintings and only altering the hair. The pose, and the absence of pubic hair, indicates that Renoir had a classical image in mind.*

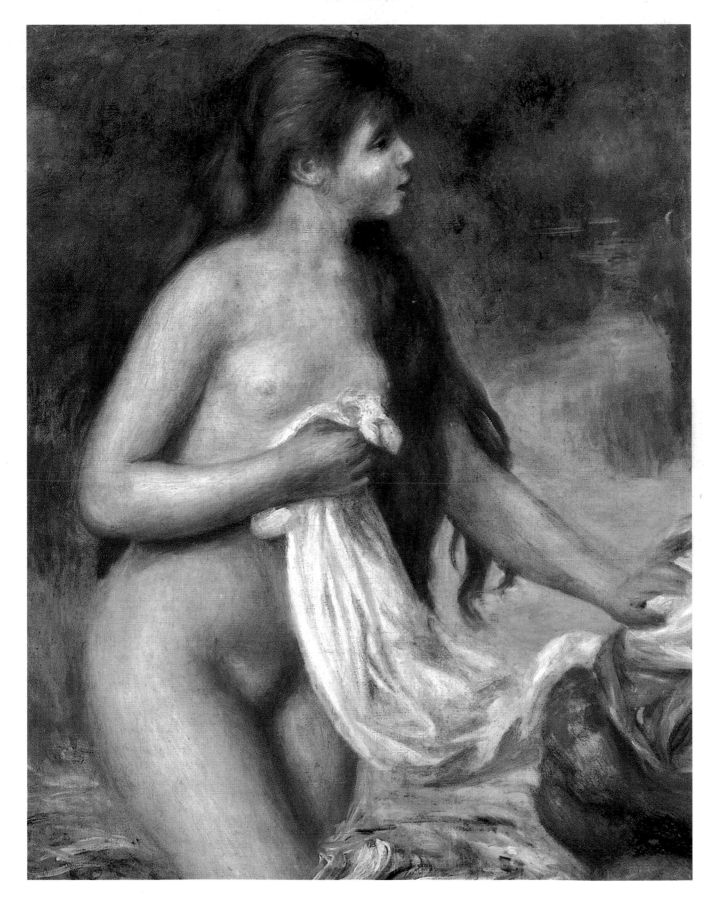

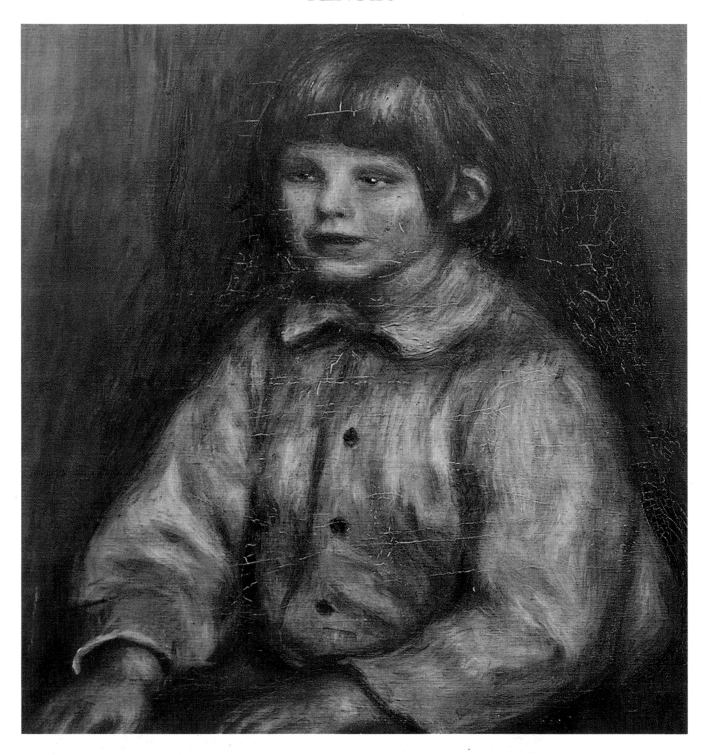

PLATE 40
**Portrait of Claude (Coco) Renoir** (1905–08)
Oil on canvas, 21⅞ x 18½ inches (55.5 x 47cm)

PLATE 41
**The Clown (Portrait of Claude Renoir)**
1909 opposite
Oil on canvas, 47¼ x 30⅓ inches (120 x 77cm)

*Renoir used his whole household as models and most of his female staff for his nude studies. These two paintings of his third son*

*Claude, nicknamed 'Coco' and born in 1901, were separated by a few years. While the smaller painting of the younger child is a relaxed, simple study, the second of Coco dressed as a clown was done after an altercation between painter and model. His female models showed remarkable acquiescence in response to Renoir's strict demands for absolute stillness, but the children objected to any prolonged period of restraint. Coco took firmly against the costume, particularly the white stockings, claiming they itched. Renoir threatened a beating to no avail and was eventually driven to bribery in the form of a box of paints and a train-set. Claude still looks unhappy and one can imagine Renoir still seething away.*

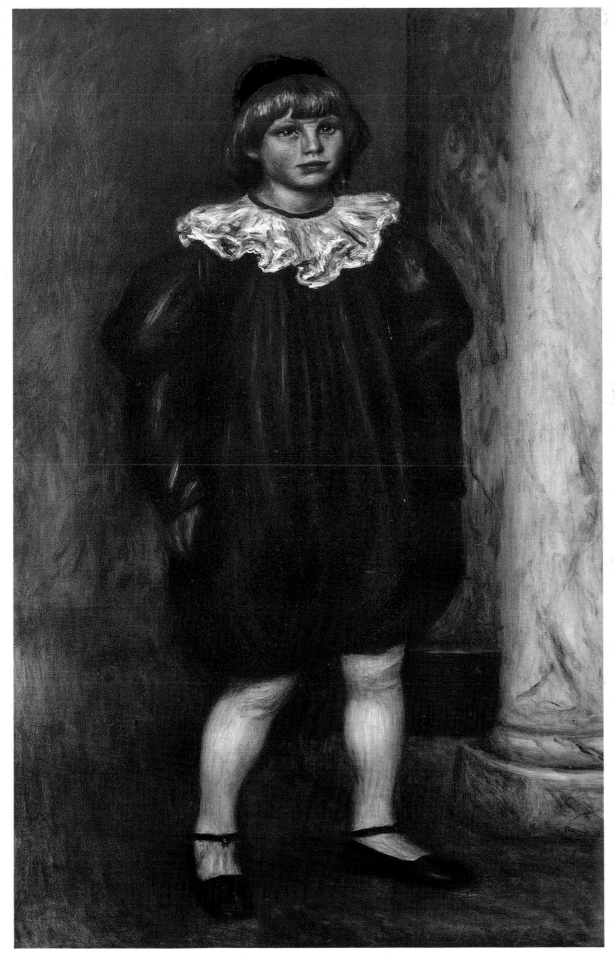

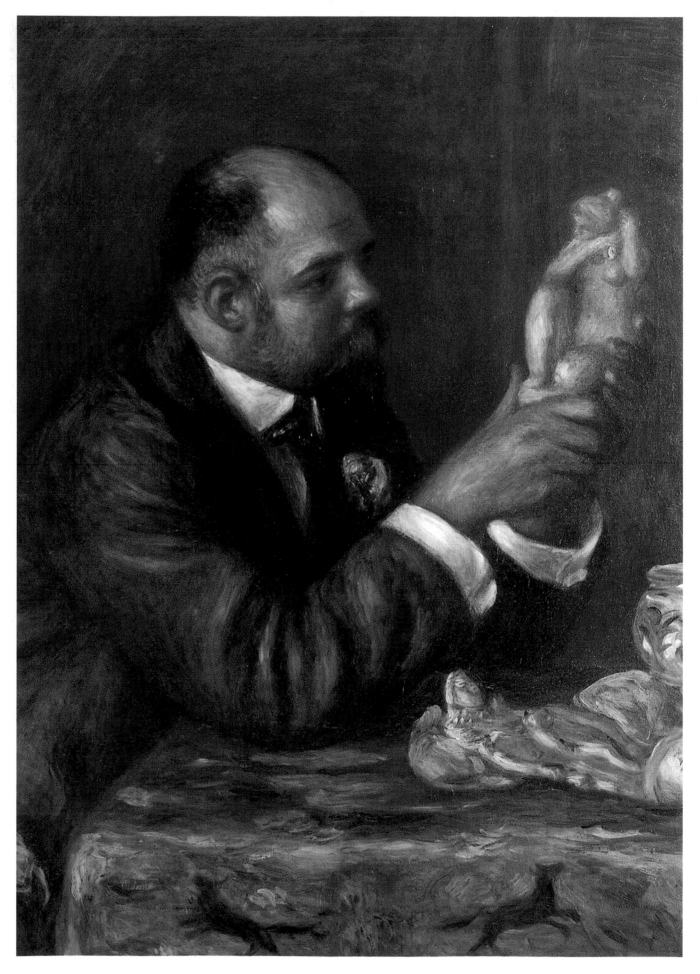

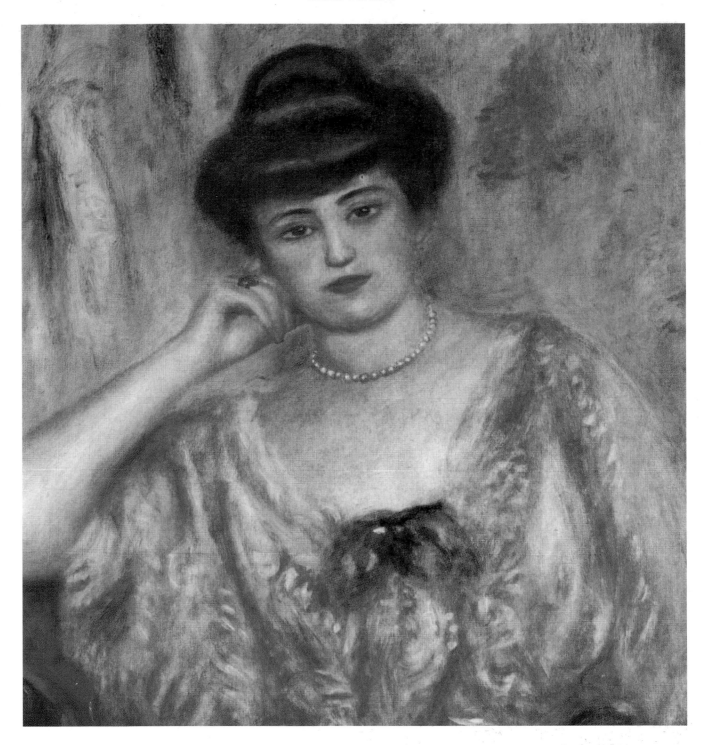

PLATE 42

**Portrait of Ambroise Vollard** (1908) opposite

Oil on canvas, 31$^1$/$_8$ x 25$^1$/$_2$ inches (79 x 65cm)

*Vollard, the Impressionist dealer, was painted by most of them
and later became the dealer for many of the early artists of the
20th century including Picasso, Matisse and Chagall. This is
Renoir's first portrait of him examining a small statuette by the
sculpture Aristide Maillol (1861-1944). He later (1917) painted
him disguised as a bull-fighter. Vollard was responsible for Renoir
turning to sculpture when arthritis inhibited his painting.*

PLATE 43

**Portrait of Mme. Edwards (Misia Sert)**
(1904) detail above

Oil on canvas, 36$^1$/$_4$ x 28$^3$/$_4$ inches (92 x 73cm)

*A late commissioned portrait, this painting reveals Renoir's
assurance and authority in the broad handling of paint.*

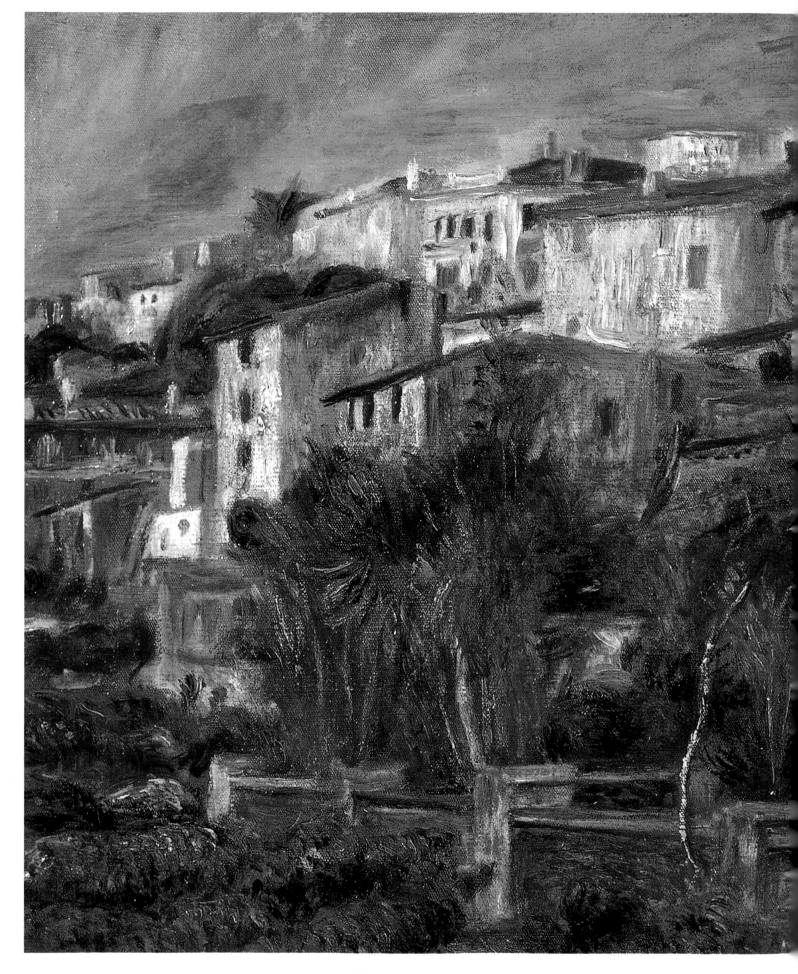

PLATE 44
## A Terrace at Cagnes (1905)
Oil on canvas, 18 x 21⁷/₈ inches (46 x 55.5cm)

*Renoir visited Cagnes-sur-Mer on the shores of the Mediterranean east of Cannes in the winter of 1899. Following this visit he formed a strong attachment to the area and as rheumatism increasingly attacked his hands began the search for a place to which he could retreat and continue painting his landscapes and the female nude studies that increasingly preoccupied him. From the beginning of the 20th century he had spent an increasing number of winters at Cagnes, and in 1907 bought a plot of hillside with an old farmhouse known as Les Collettes on which he built a house and studio. His land faced the small ancient hill-town of Hautes Cagnes, and the painting illustrated here is a view of a terrace on the outskirts of that town, completed before he bought Les Collettes. The deterioration of control and refinement, the result of his crippled hands and diminished eyesight, are apparent in this canvas, as is also his determination to continue working.*

PLATE 45
## Venus Victorious (1914) page 68
Bronze, over life-size

*Venus is here depicted holding the golden apple awarded to her by Paris, a mythological theme that Renoir found fascinating in his later life and made the subject of a number of works. His sculptures, due to the crippling effects of arthritis, were actually made by his assistant/partner Richard Guino who was introduced to him by Ambroise Vollard.*

PLATE 46
## Mother and Child (c.1916, cast 1927) page 69
Bronze, height 21¹/₄ inches (54cm)

*A study of Madame Renoir nursing her first child Pierre. Executed after her death in 1915, it is possible that it was a study for a larger commemorative piece to be placed on her tomb.*

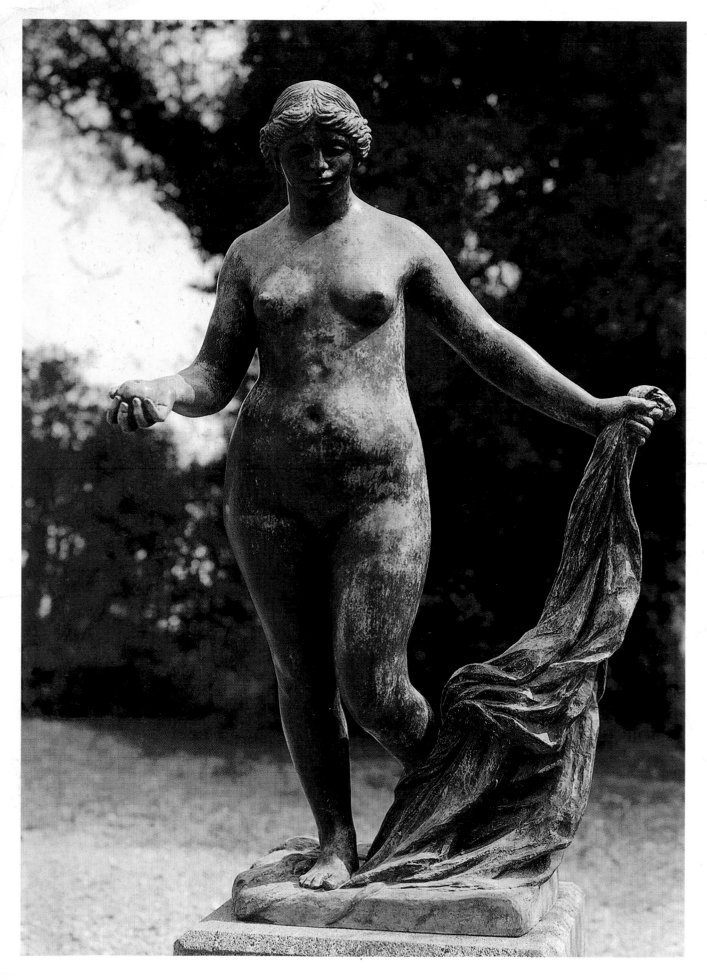

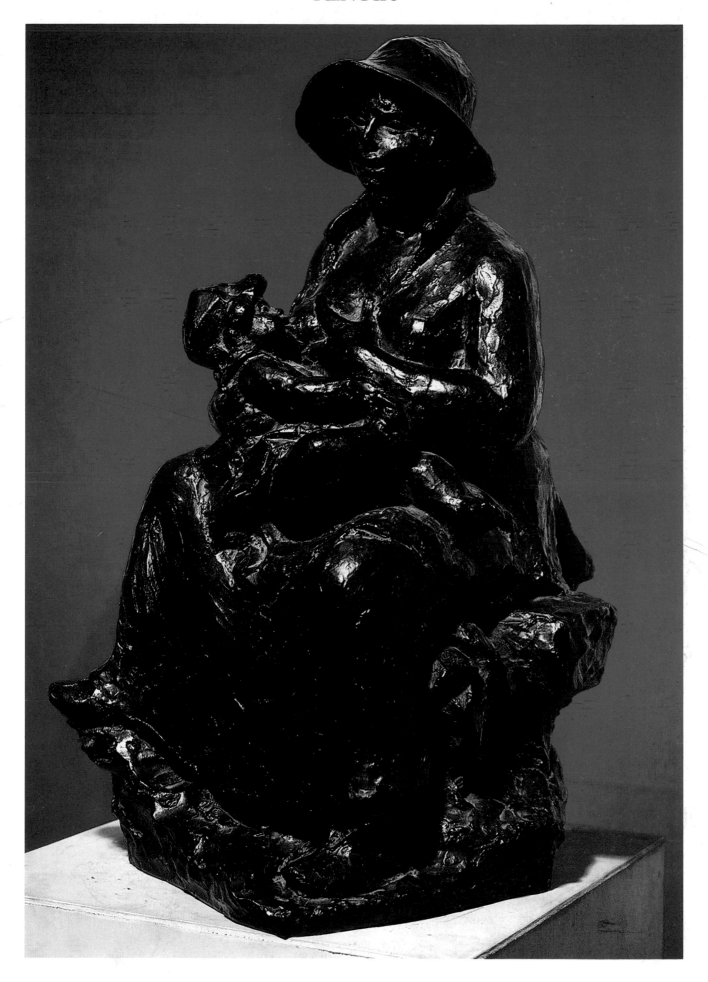

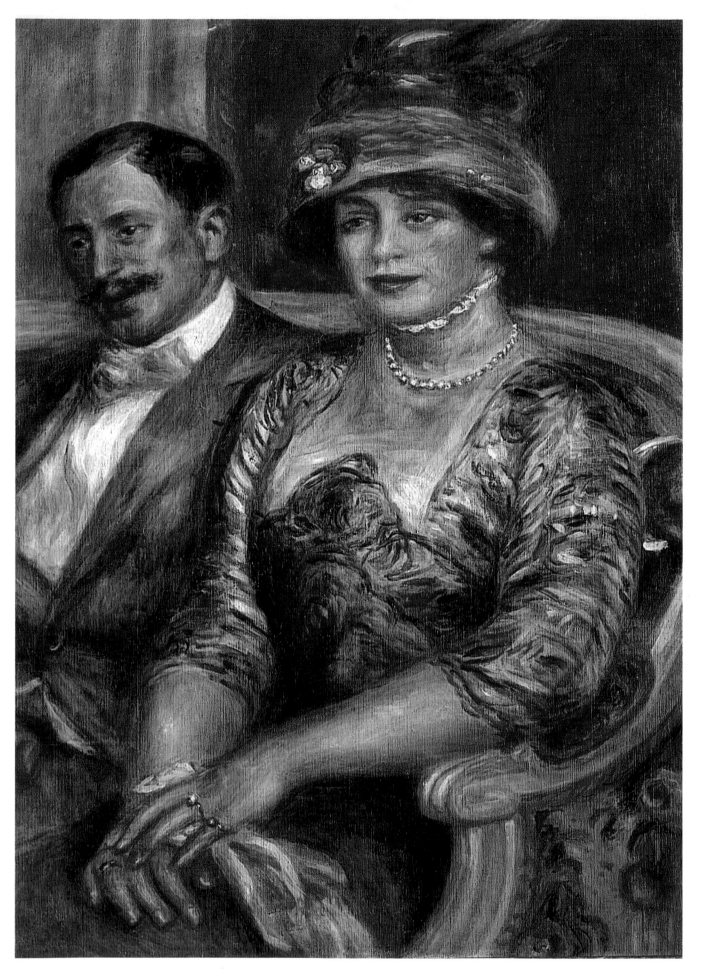

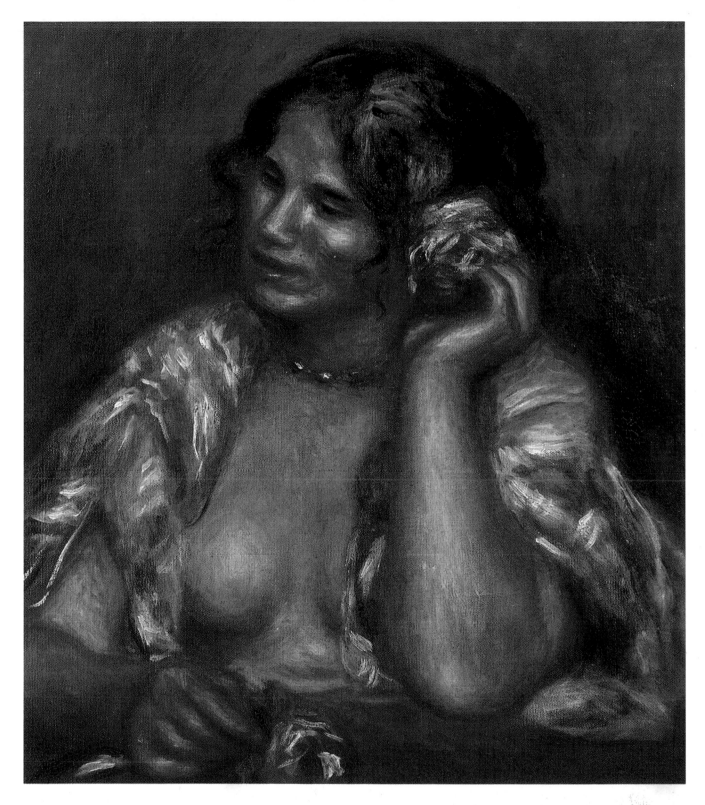

PLATE 47
**M. & Mme. Bernheim de Villers** (1910)
opposite
Oil on canvas, 31⁷/₈ x 25³/₄ inches (81 x 65.5cm)

*A commissioned portrait of the art dealer Gaston and his wife
Suzanne when Renoir was at the height of his success.*

PLATE 48
**Gabrielle with a Rose**
Oil on canvas, 21⁷/₈ x 18¹/₂ inches (55.5 x 47cm)

*Gabrielle Renard was a frequent model as well as the family
servant and this study shows her in a semi-transparent blouse
with barely covered breasts toying with a rose in her hair. A
dreamily erotic image*

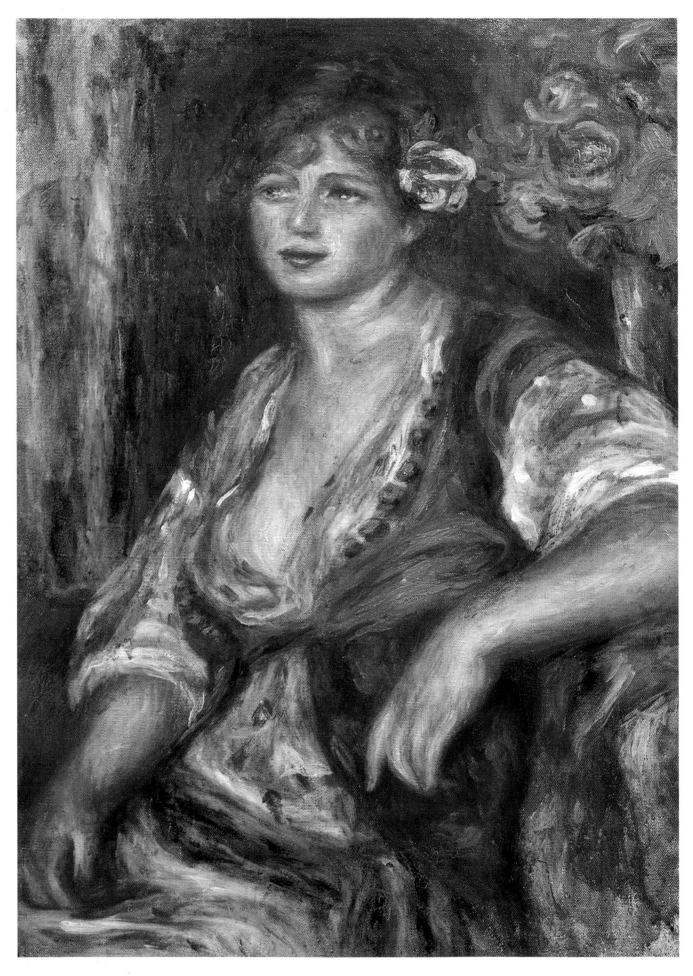

PLATE 49
**Portrait of Mlle. Françoise** (c.1915) opposite
Oil on canvas, 25$\frac{1}{2}$ x 20$\frac{7}{8}$ inches (65 x 53cm)

*Similar in character to the previous painting, this is one of which there is another similar and the sitter appears, like Gabrielle, in a 'sweet disorder of the dress'. Renoir was not averse to changing details of colour and scale if it coincided with his feeling for the image he wished to achieve.*

PLATE 50
**The Bathers** ( c.1918–19) overleaf
Oil on canvas, 43$\frac{1}{3}$ x 63 inches (110 x 160cm)

*This painting, sometimes, if surprisingly known as The Nymphs, is the most significant of Renoir's baigneuses, a theme he had pursued through most of his painting career. The earlier Grandes Baigneuses of 1884–87 (plate 34) was in a sharply defined linear form – his harsh period – whereas this is painted with soft reverence for form and not edges. It should be remembered that when he painted this work he had for some years been crippled with arthritis in his hands and was now unable to walk. He was living in Cagnes, his wife had died, and the world was at war. The avant garde art of the day had already spawned Fauvism, Cubism, Futurism, German Expressionism and Surrealism was*

*incipient. The work on this painting must have begun about the time of the Armistice of 11 November 1918 and possibly was even inspired by the personal culmination of Renoir's own career – at all events his son Jean thought so. Compared with earlier work on the same theme so popular with Renoir, it reveals a new depth of spirit, a surface sunlit calm, almost an idyllic presentation of the physicality of human female sensuality in a lush verdant world. For this work he employed a new 16-year-old red-haired model, Dédée Hessling, who after Renoir's death became Jean's wife. There is something movingly appropriate in the finale to Renoir's career.*

*As frequently happens, the painting was not appreciated by all at the time and many did not admire his later paintings, particularly his nudes. Mary Cassatt, the American Impressionist, had described them in 1913 as 'awful pictures ... of enormously fat red women with small heads'. But if looked at with sympathetic and understanding eyes they become images of great pictorial power, full of the grandeur of human sensuality without its darker side.*

*It is the core of Renoir's oeuvre that whatever his subject, whether he was attempting a classical subject or the most intimate personal study, his joy in living nature and devotion to his art inspired some of the most memorable images of the 19th century.*

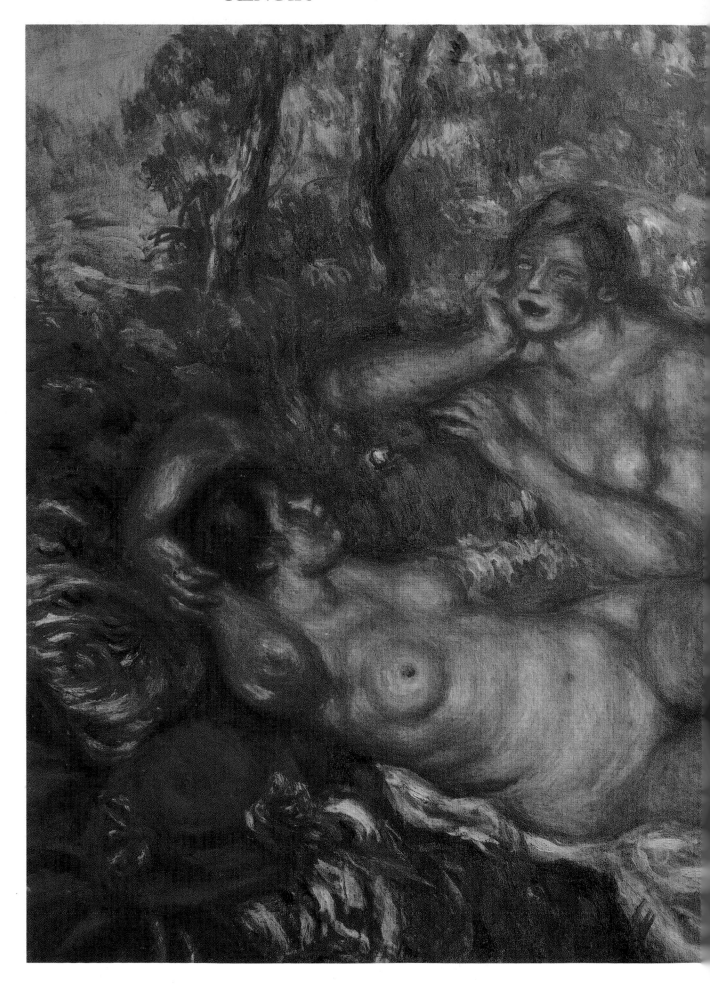

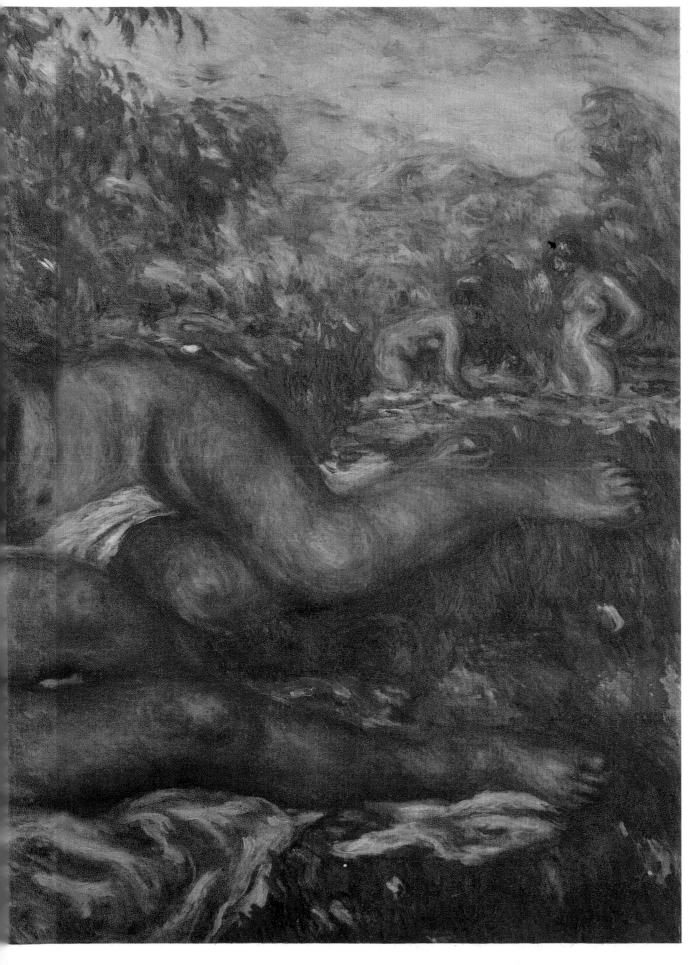

# ACKNOWLEDGEMENT

*The Publishers wish to thank the following for providing photographs, and for permission to reproduce copyright material. While every effort has been made to trace and acknowledge copyright-holders, we wish to apologize should any omissions have been made.*

**Photograph of Pierre-Auguste Renoir**
*Larousse Archives/Giraudon, Paris*
**The Painter Lacoeur in the Forest of Fontainebleau**
*São Paulo Museum of Art/Giraudon, Paris*
**Portrait of Frédéric Bazille**
*Louvre/Giraudon, Paris*
**Lise with a Parasol**
*Folkwang Museum, Essen/Giraudon, Paris*
**Boy with a Cat**
*Musée d'Orsay/Giraudon, Paris*
**Bather with her Griffon**
*São Paulo Museum of Art/Giraudon, Paris*
**La Grenouillère**
*Pushkin Museum, Moscow/Giraudon, Paris*
**Portrait of Claude Monet**
*Musée Marmottan/Giraudon, Paris*
**Portrait of Claude Monet**
*Musée d'Orsay/Giraudon, Paris*
**La Loge**
*Courtaud Institute Galleries/Bridgeman/Giraudon, Paris*
**Path Winding Upwards through Tall Grass**
*Musée d'Orsay/Giraudon, Paris*
**Woman Reading**
*Musée d'Orsay/Giraudon, Paris*
**Young Woman Wearing a Veil**
*Musée d'Orsay/Giraudon, Paris*
**Nude Study: The Effect of Sunlight**
*Musée d'Orsay/Giraudon, Paris*
**Le Moulin de la Galette**
*Musée d'Orsay/Giraudon, Paris*
**Parisian Women Dressed as Algerians**
*National Museum of Western Art, Tokyo*
**The Swing**
*Musée d'Orsay/Giraudon, Paris*
**Les Grands Boulevards**
*Philadelphia Museum of Art.*
*The Henry P. McIlhenny Collection in memory of Frances P. McIlhenny*
**Madame Charpentier**
*Musée d'Orsay/Lauros/Giraudon, Paris*
**Madame Charpentier and her Children**
*The Metropolitan Museum of Art, New York*
**Portrait of Jeanne Samary**
*The Hermitage Museum, St Petersburg/Giraudon, Paris*
**Portrait of Alphonsine Fournaise**
*Musée d'Orsay/Giraudon, Paris*
**Portrait of Stéphane Mallarmé**
*Château de Versailles/Giraudon, Paris*
**The Luncheon of the Boating Party**
*Phillips' Collection/Giraudon, Paris*
**Dance at Bougival**
*Boston Museum of Fine Arts*

**Dance in Town**
*Musée d'Orsay*
**Dance in the Country** (see opposite)
*Musée d'Orsay/Giraudon, Paris*
**Renoir with his family** (photograph)
*Hulton Getty*
**Renoir at work in his studio with model** (photograph)
*Hulton Getty*
**Renoir's House at Cagnes** (photograph)
*Hulton Getty*
**Renoir's Studio**
*Hulton Getty*
**Renoir's Studio, showing his easel and wheelchair**
*Lauros/Giraudon, Paris*
**An exterior of his house Les Collettes, at Cagnes, taken in 1908.**
*Lauros/Giraudon, Paris*
**Les Parapluies (Umbrellas)**
*The National Gallery, London/Bridgeman/Giraudon, Paris*
**In the Luxembourg Gardens**
*Private Collection, Geneva/Giraudon, Paris*
**Les Grandes Baigneuses (The Bathers)**
*Pennsylvania Museum of Fine Art, Philadelphia/ Bridgeman/Giraudon, Paris*
**Montagne Sainte-Victoire**
*Yale University Art Gallery, New Haven, Connecticut.*
*The Katherine Ordway Collection*
**Madame de Bonnières**
*Musée du Petit-Palais/Lauros/Giraudon, Paris*
**The Rambler**
*Musée des Beaux-Arts André Malraux, Le Havre/Giraudon, Paris*
**Berthe Morisot with her Daughter**
*Musée du Petit-Palais/Giraudon, Paris*
**Bather with Long Hair**
*Musée de l'Orangerie/Lauros/Giraudon, Paris*
**Portrait of Claude (Coco) Renoir**
*São Paulo Museum of Art/Giraudon, Paris*
**The Clown (Portrait of Claude Renoir)**
*Musée de l'Orangerie/Lauros/Giraudon, Paris*
**Portrait of Ambroise Vollard**
*Courtaud Institute Galleries/Bridgeman/Giraudon, Paris*
**Portrait of Mme. Edwards (Misia Sert)**
*Giraudon, Paris*
**A Terrace at Cagnes**
*Bridgestone Museum of Art, Tokyo/Giraudon, Paris*
**Venus Victorious**
*Renoir Museum, Les Collettes, Cagnes-sur-Mer/Lauros/Giraudon, Paris*
**Mother and Child**
*Renoir Museum, Les Collettes, Cagnes-sur-Mer/Lauros/Giraudon, Paris*
**M. & Mme. Bernheim de Villers**
*Musée d'Orsay/Lauros/Giraudon, Paris*
**Gabrielle with a Rose**
*Musée d'Orsay/Giraudon, Paris*
**Portrait of Mlle Françoise**
*Musée de l'Orangerie/Lauros/Giraudon, Paris/Knudsens*
**The Bathers**
*Musée d'Orsay*